KLEE
Douglas Hall

Phaidon Press Limited
140 Kensington Church Street, London W8 4BN

First published 1977
This edition, revised and enlarged, first published 1992
© Phaidon Press 1992

A CIP catalogue record of this book is available from the
British Library

ISBN 0 7148 2730 4

Printed in Hong Kong

The publishers with to thank all private owners, museums, galleries
and other institutions for permission to reproduce works in their
collection.

Cover illustrations:
(front) *Senecio* 1922. (Plate 9).
(back) *Kettledrummer* 1940. (Plate 47).

Klee

Few painters have filled in their own artistic birth certificates with such emphasis and clarity as Paul Klee. He did so in Kairouan in Tunisia, on 16 April 1914. On that day Klee entered in his diary: 'Colour possesses me ... That is the meaning of this happy hour: colour and I are one. I am a painter.'

Klee was then already thirty-four. He was born on 18 December 1879 near Bern in Switzerland, the son of Hans Klee, a teacher of music, German by birth and nationality. Paul's mother, like her husband, had been trained as a musician. As a boy Klee learned to play the violin to near-professional standard. Later, after his marriage in 1906 to the pianist Lily Stumpf, musical evenings were a regular part of his family life. In establishing the freedom of the visual arts to act independently of representation, the analogy with music was very important and Klee was well qualified to understand both the use of this analogy and its limitations.

Klee's appearance was unusual. Will Grohmann, who knew him well, refers to his exotic appearance, with yellowish skin like an Arab's, high domed forehead, large brown eyes, and a deliberate gravity, which expressed itself in sparing words. Photographs bear out Grohmann's recollections (Fig. 1). Klee's diaries, which he kept from 1898 to 1918, are evidence that he lived his imaginative life at a high level of intensity, the entries sometimes bordering on an unforced surrealism, though often mixed with sharp observation and acid comment.

As well as his training in music, Klee received a thorough academic education. One thing that remained with him from school was a knowledge of Greek, which he continued to read throughout life. As well as possessing a knowledge of Greek and of French classics, he was aware of the advances of contemporary French and German art, literature and music.

Klee graduated from the *Literarschule* in Bern in 1898. Through his later schooldays he had hesitated between music and art as a career, but by that time his mind was made up. Now came the decision that all ambitious young provincial artists had to make: where to study art? He chose Munich. In 1940, shortly before his death, Klee put the reasons for his decision simply: 'The realization of my aim at that time – and the same would be true in part today – led me abroad. I had to choose between Paris and Germany, and my feeling for Germany was the stronger. That is how I came to go to the Bavarian capital.'

Munich, then, it was. If Klee had chosen Paris the development of his art and even of modern art in general would surely have been different. The English-language version of the history of modern art has given Paris the undisputed leadership. But Klee was German, and to go to Munich in 1898 was quite appropriate. The Symbolist current was flowing strongly in Europe, not only in Paris. The arrival of Symbolism caused the march of French pictorial logic to falter, allowing a number of artists of genius, from outside France, to arrive on the international

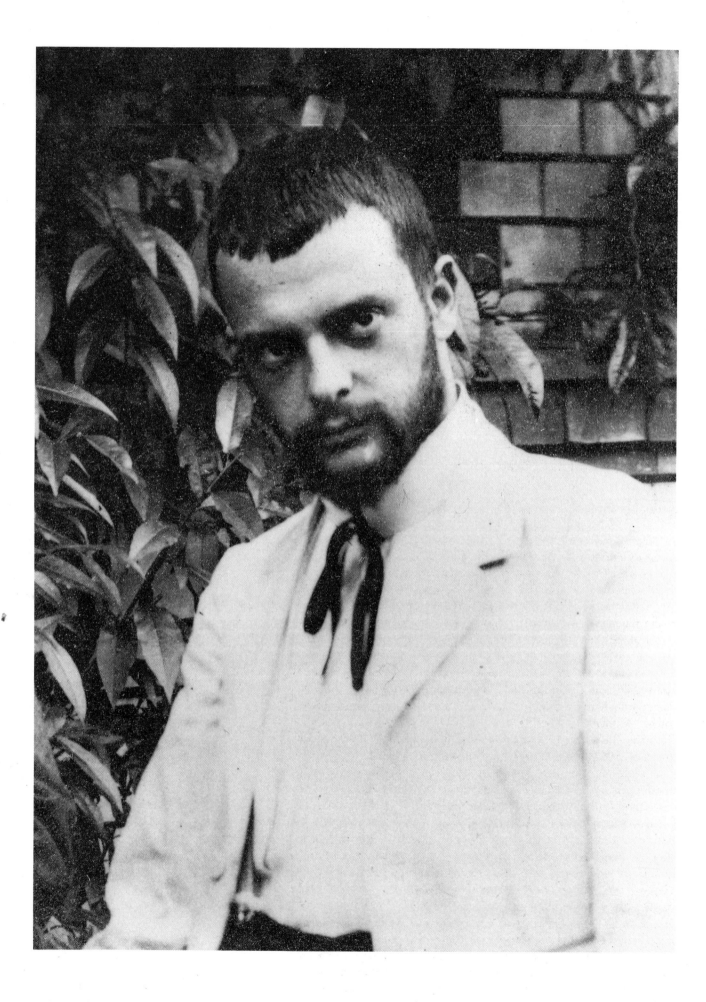

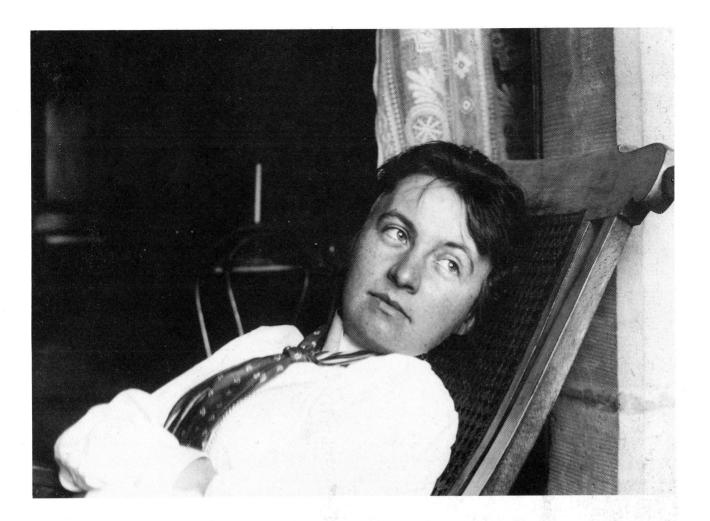

Fig. 2
Photograph of Lily
Stumpf, later Klee,
Bern 1903

scene with profound effect on the history of art.

Werner Haftmann suggests that the German spirit of idealism asserts itself 'whenever Western man longs for clarification of the inner worlds, for images that rise to the surface from the innermost depths'. The end of the nineteenth century was such a time, and for such underlying reasons Klee's attachment to Germany was historically fortunate. It was not initially, or in the main, German-born artists who assisted this imagery to the surface, but men from the periphery, like the Norwegian, Munch, and the Russian, Kandinsky – un-Latin temperaments who found in Germany, rather than France, a sympathetic sphere. Munch and Kandinsky spent their most formative years in Germany. The latter had arrived in Munich from Russia, at the age of thirty, in 1896, just two years before the youthful Klee.

In 1892 the Secession movement took organized form in Munich, cracking open the tight control over exhibition space exercised by academic and history painters. Impressionism, Symbolism, and 'nature-lyricism' were practised by the artists, both German and foreign, who supported the breakaway in 1892. They included Franz von Stuck, who became a professor at the Academy in 1896 and taught both Kandinsky and Klee. In 1896, also, the periodicals *Jugend* and *Simplicissimus* were founded in Munich. *Jugend* (its slogan: Youth is on the March) was to give rise to the term *Jugendstil*, which replaced 'English style' as the generic name for *art nouveau* in Germany. Munich was a major centre of *art nouveau* with its insistence on the unity of 'fine' and 'applied' art and architecture, and its sometimes facile belief that the aim of all plastic art was to convey feeling or 'soul'. Practitioners of *Jugendstil* were among the first to realize that this could be done by non-objective means. Munich provided the artistic environ-

Fig. 1
Photograph of Paul
Klee, Bern 1906

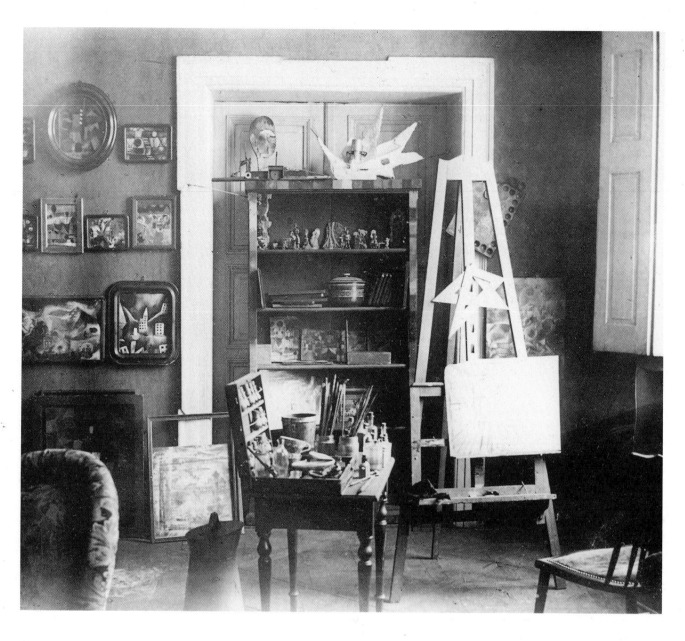

Fig. 3
Paul Klee's studio in
Munich, 1920

ment which supported Kandinsky and his quiet revolution. By 1911, when Kandinsky formed the Blaue Reiter group, Klee had experienced his magnetic influence and had wondered at his strange new paintings. Later the two artists were to be close friends and colleagues for many years at the Bauhaus.

Klee arrived in Munich in October 1898 and at first studied privately. He entered the Academy a year later, and after another year joined von Stuck's class. Instead of a further year at Munich, he travelled in Italy from October 1901 to May 1902. He sensed that his academic art education in Munich had not been a success, and he did not resume it. He was not yet able to benefit from Munich as an alternative centre of modern art. Slowly recognizing what sort of artist he was, he resigned himself to a period of self-discipline and self-education in Bern. He did not lose touch with Munich, for he had become engaged to Lily Stumpf and visited her there (Fig. 2). They were married in September 1906, and Klee then settled permanently in Munich.

Modern art had flowered in Munich in the five years since he had left it. Now he could begin in earnest to catch up with recent developments in art. He saw Impressionists and Post-Impressionists newly acquired for the Neue Pinakothek. He was carried away by an exhibition of Van Gogh, and deeply impressed by Cézanne. He began slowly to meet his

contemporaries in the avant-garde although his diaries say little about his reactions to them. Of those he came to know, he was closest to Franz Marc, and after him to Kandinsky. He paid short visits to Paris in 1905 and in 1912, when he met Robert Delaunay, perhaps the strongest influence outside his immediate circle. He visited North Africa in 1914 and felt a conviction that his apprenticeship was over and that he was a complete painter. Then came the First World War. Klee was not immediately called up, but in March 1916, aged 36, he was called for infantry training. It was an enforced pause in his activity, which offers an opportunity to sum up his long period of formation, with help from the voluminous diaries he kept during, and only during, this period.

Paul Klee was part poet and visionary, part disciplined, methodical craftsman and well-regulated bourgeois. His background and education had emphasized the latter aspect; and his development was slow partly because it took him time to be equally aware of its opposite. In Italy and afterwards in Bern he was discovering himself and realizing that as a creative painter he was, in his own words, more 'poetic' than 'pictorial'. Self-realization led him to appreciate the towering contrasts and dichotomies of art, and the smallness of the individual painter before them. In a 'Recapitulation' inserted in his diary for July 1902 after the Italian tour (but presumably written some years later) he wrote: 'Now, my immediate and highest goal will be to bring architectonic and poetic painting into a fusion, or at least to establish a harmony between them.'

During the following years, Klee left scattered clues in his diaries about his transition from painstaking student of pictorial draughtsmanship to creative master of painting. In June 1905 Klee, who had already practised the art of glass-painting, blackened a sheet of glass and drew on it with a needle. He found he had combined two kinds of energy – line and light: 'energy illuminates'. By 1908 he is writing more freely about the technique of painting, although on Shrove Tuesday, 1910, he professes himself 'still incapable of painting'. In March there was another and decisive step: 'and now an altogether revolutionary discovery: to adapt oneself to the contents of the paintbox is more important than nature and its study. I must some day be able to improvise freely on the chromatic keyboard of the rows of watercolour cups.'

The discoveries and realizations of that time implied the development of a world view of art and life that was not always entirely joyful: 'One deserts the realm of the here and now to transfer one's activity into a realm of the yonder, where total affirmation is possible. The more horrible this world (as today, for instance), the more abstract our art, whereas a happy world brings forth an art of the here and now. This may be recognized as an echo of the thesis of Wilhelm Worringer in *Abstraction and Empathy*, published in 1908 and much talked of in the Kandinsky circle. By 1911 Paul Klee was not only a fully fledged painter but an intellectually formed modern artist, capable of assessing the exciting movements happening around him.

A book like this is too short to deal with Klee's art before he declared himself a painter, as we have seen, in 1914. He was already a graphic artist of consummate skill, and a deeply thoughtful and cultivated individual, as his diaries show. The foundations of Klee's keen curiosity and insight into the growth forms of nature were laid at a very early age. But there is too much of a Hamlet, 'sicklied o'er with the pale cast of thought', about the early Klee, which gives the work an ambiguity, a brooding melancholy and indecision (Fig. 4). His discovery of the chromatic and other possibilities of modern art liberated him from it, and created a sharp division between the early work and the main body of his output. In this book we illustrate only one work of before 1914, a

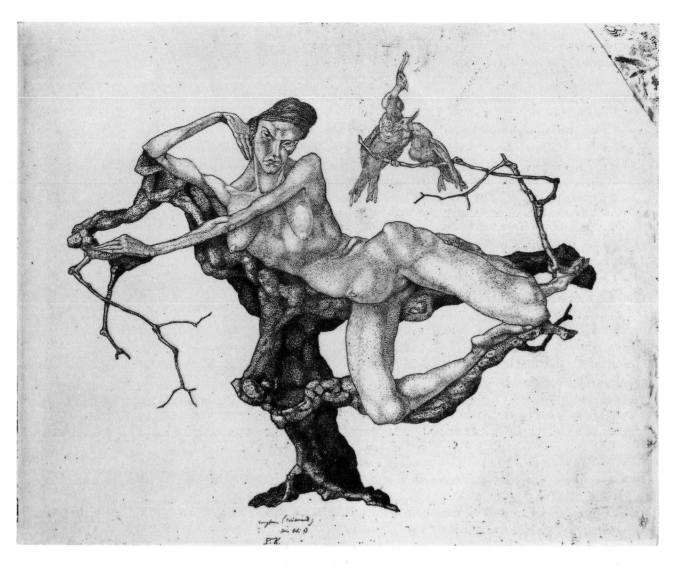

Fig. 4
Virgin in a Tree
1903. Etching,
28.7 x 29.7 cm.
Paul Klee Foundation,
Kunstmuseum, Bern

self-portrait, *The Artist at the Window* of 1909 (Plate 1). This is an early example of Klee's use of watercolour as an independent medium and not an adjunct to drawing. There are outlines to the figure, but they are made of light coming from behind and are part of the form. The painting is composed on modern principles, that is, all the visual incidents and values in it are projected forward on to the surface as on to a screen, and are not located in space. Klee could have learned this from a number of sources, though the most likely one is Matisse, whose work he had seen the previous year in Munich, and for whom this type of composing was habitual. But Matisse's influence would not account for the particular distortions visible here. All Klee's work between 1902 and 1914 involved the problem of deformation and its expressive possibilities. Grohmann states that he went to the length of using a wrongly adjusted pantograph to obtain controlled distortions, which could suggest possibilities for new constructions.

The huge step forward taken by Klee in 1914 can be judged by comparing this self-portrait with the next pair of plates, both paintings of 1914. *Red and White Domes* (Plate 2) expresses the direct result of his Tunisian experience; *On a Motif from Hamamet* (Plate 3) relates more closely to the work of Robert Delaunay. The speculative and theoretical bent of the French artist must have been congenial to his way of thinking; possibly also Delaunay was more accessible than Braque or Picasso. Those pictures of Delaunay that influenced Klee were a series called *Windows*, small, crystalline paintings divided into rectangles and triangles of pale, iridescent colours without linear boundaries.

It may be helpful in looking at the two Klees (Plates 2 and 3) to use the clue provided by Delaunay's title. These works can be conceived as the view outside seen through a window of small and irregular panes. Each pane attracts to itself a small segment of the total view, mingles it with light of varying intensity, imparts to it a characteristic colour and delivers it to the spectator as part of a crystalline re-structuring of the scene outside. This is a very attractive artistic idea. It neatly stands on its head the old conception of a picture as a magic window. And the use of a grid – which our small-paned window really is – to control or structure chaotic nature has a long history. It was imposed on the visible world as a *schema* or used as a practical device to enable appearances to be measured and copied. A well-known woodcut by Durer shows an artist using such a grid. The grid is a symbol of measure, and has always formed the basis of classical composition. No wonder that for modern artists it has been of particular importance, sometimes all-sufficient. Klee was to have recourse to it again and again.

Although Klee thought that Delaunay was moving into complete abstraction, the *Windows* are little more abstract than late Cézanne. Cézanne provided an even more basic precedent than Delaunay in such matters as the unifying grain of the parallel brushstrokes and the vitally important boundaries where planes of colour meet. These qualities and the delicate harmonies of the colours themselves, forming a structure of equal integrity and lyricism, show Klee making good his intention to fuse architectonic and poetic painting. It is this dualism in Klee that distinguishes him fundamentally from Delaunay; in fact it is the very basis of Klee's art. In *Red and White Domes* dualism permits him the un-Delaunay-like device of inserting visual clues (absent in Plate 3), in a minor, peripheral place, which add an entire new level of meaning. The outlines of the domes themselves, and some small rectangles which can be read as windows resolve the work into a crystalline version of a North African townscape in the dying heat of the day. 'My head is full of the impressions of last night's walk', wrote Klee on the day after his arrival in Tunis. 'Art – nature – Self. Went to work at once and painted in watercolour in the Arab quarter. Began the synthesis of urban architecture and pictorial architecture. 'And later, 'an evening of colours as tender as they were clear'.

Klee's war service did not cause the catastrophic interruption to his development that many artists suffered. He was not sent to the front and he escaped most of the horrors. Attached to an air force reserve unit far back in Germany, he was even able to do some painting, thanks to the small scale on which he habitually worked. He worked on damaged aircraft and used to paint their numbers and insignia. The appearance of the first war aircraft with their exposed structure, tension wires, stretched fabric and insignia, is highly sympathetic to Klee's later work and must surely have entered into his visual imagination (Plates 10 and 11). Klee sometimes used small pieces of aeroplane fabric to paint on. This was an important innovation for him. The material was relatively coarse in weave, and presumably came into Klee's hands with irregular edges. To understand the significance of such material it is necessary to understand Klee's attitude to technical matters.

As a graphic artist Klee had been a meticulous and experimental craftsman. His 'Tunisian' watercolours were technically simple, but soon, whether prompted by his aeroplane fabric or not, he began to experiment with a great variety of techniques. This experimentation must not be confused with a restless search for 'effects'. Every 'effect' used by Klee has its own proper role, and becomes inseparable from the

meaning of the work. With Klee, idea and realization are one thing. That is the reason for the very concrete, material nature of his work. Although all the pioneer modern painters rejected illusionism, most were content to go on using a technique primarily designed to create illusion, i. e. oil colours on a stretched canvas, the edges of which were customarily hidden by a frame. Or they used watercolour on a sheet of paper similarly treated.

Klee used a stretched canvas very seldom indeed. When he used canvas (and he used both coarse and fine with equal judgement) he allowed the edge to show, laying the canvas down on a board. His drawings and watercolours are often mounted on a larger sheet leaving a margin on which Klee would write the title, rule a line underneath, and add the inventory number. Edges and textures were both of vital concern to Klee. The edge of a work determines its relationship with the space beyond its boundaries. Klee did not seek to create the illusion of life beyond the frame. To him, the content of the work seemed to belong naturally to the pictorial field and to exist only by virtue of it.

Look at, for example, *Fruits on Red* (Plate 29). This is painted on a red silk handkerchief used by Klee when playing the violin. The edge, and the fine quality of the thin material, dictate the style – few and fine lines, which enter from three sides, branches bearing a load of 'fruits', whose relationship to the edge of the cloth is all-important in their placing. Some of the 'fruits' are themselves small pieces of fabric. By these means Klee makes the work entirely self-sufficient – an imaginative construct raised on the foundation of a small piece of reality (the handkerchief). Where Klee used an elaborate technique for laying the ground and achieved a rich texture, it was to intensify the 'concrete' nature of the work and give its material essence a special personality. A small canvas or panel prepared in this way takes on a precious and almost venerable appearance, making us look more carefully and curiously at the imagery represented on it.

Klee was fortunate to be able to return unscathed to his home in Munich in December 1918 and resume his painting with little spiritual sense of interruption. It is true that the avant-garde circle in Munich had been dispersed. Macke and Franz Marc had been killed. Kandinsky had returned to Russia, Jawlensky had gone to Switzerland. But Klee was not dependent on a circle to be able to work and to progress. He continued to develop his ideas quietly in Munich. At least one work painted in 1918, while he was still in uniform, already establishes a type of Klee that recurred again and again over the next fifteen years and is the foundation of his later popularity: *Hermitage* of 1918 (Plate 4). Grohmann calls such works illustrations to a 'cosmic picture book'. They derive, inevitably, from the Tunisian paintings, but introduce a new feeling. The atmosphere has switched to a northern fairy tale. In the middle of a conifer forest, peopled only by birds, there is a low hill crowned by a cross, and beside it a little building with a pinnacle. There are other symbols, not readily interpreted. At top and sides Klee shows the folds of a curtain. We may be intended to see the scene, then, as a stage set, awaiting the entrance of actor or dancer. Klee was fond of the theatre, and theatrical, especially operatic, allusions are frequent in his work. His only practical experience of stage-craft, however, seems to have been the puppets and puppet-theatre he made for his young son Felix, for which Plate 7 may possibly be a back-drop. Surprisingly, there is no evidence of his direct involvement with the Bauhaus theatre. He does not seem to have seen 'Les Ballets Russes', which scored such an electric success in 1909 and 1910, and continued in favour until Diaghilev's death in 1929. Klee's *Hermitage*, far from the

thorough structuring of Delaunay, seems closer to the sophisticated folksiness of the stage sets designed for Diaghilev by the advanced Russian artist Natalia Gontcharova. Klee might have known about her work from his friends Kandinsky and Jawlensky, but such a connection cannot be proved.

In works like *Hermitage* Klee establishes once and for all the ability to create a quasi-logical world having enough points of contact with the real one to provide a parallel text, so to speak, for its interpretation. These works put Klee on the level of wit and humour on which he remained for the rest of his life, even though irony was always in the background and tragedy just around the corner. Along with the humour goes a certain deliberate naivety, a childlike simplicity that often deceives the unwary into thinking Klee a lightweight artist.

In 1919 and 1920 and for a few years following, Klee consolidated what he had learned from Delaunay by a number of tightly structured, small paintings. *Red Balloon* of 1922 (Plate 8) is one of the later of these. It is in oil, but applied to muslin primed with chalk and mounted on a board, a typically Klee technique resulting in translucency of colour contrasting with the evident texture of the support. Almost everywhere the planes of colour are bounded by lines, one of the most obvious differences with a painting of 1914 like Plate 2, and with the denser, more richly painted oils of 1919 such as *Villa R* (Basel, Fig. 15). There is still the underlying basis of a grid composition, but it is not carried over the whole space. The relationship between the content and the abstract form is much the same.

In *Red Balloon* a brilliantly designed linear and colour composition of great charm offers a fairly specific interpretation. The interconnected rectangles stand for balconies, window-shutters and door, with the whole design keyed into place by the sloping roof top right. Bottom left a little square or yard appears, beyond it a large gate, the beginnings of roofs, a domed building which is perhaps a plant-house, as faint tree-like outlines can be seen within it (the Botanical Garden is a favourite theme of Klee's). The most specific image is the balloon itself with its basket and cable. The imagery is in no way laboured, the interpretation is offered rather than demanded. The basis of Klee's detachment in that respect is his growing confidence and skill in handling abstract elements. We can study how he used them in another painting of near this time, *Senecio* of 1922.

Senecio (Plate 9) is one of the works that the thoughtless might dismiss as 'childish', although it is pure vintage Klee. *Senecio* is the botanical name of the genus including cineraria and ragwort, and Klee is probably comparing the moon-faced person with the round flower of *Senecio*, the eyes with the shape of the petals and the pupils with the prominent seed-heads of cineraria. He was often to return to these round heads in future years (Plates 35 and 37). Both the content and the construction were important to Klee, whose art rested on the twin supports of nature and geometry. Anyone who thinks seriously about abstract design must soon be led to ponder the relation between the circle and the square. Plates 8 and 9 show different ways of playing them against each other. *Senecio* cunningly absorbs the circle into a rectilinear structure still dependent on Delaunay. By using it sparingly, Klee was always able to give the circle a special potency (Plates 28, 29 and 34).

How important was it to Klee that his works should be *read* in such ways? His views are made plain in the speech he gave at the opening of an exhibition of his work at Jena in 1924, published in English as *On Modern Art*. Klee is most of all concerned to describe what he called 'the

specific dimensions of pictorial art', the use of which must, he says, be accompanied by distortion of the natural form; 'for therein is nature reborn'. But the question for us is: how are we to recognize and name this re-birth? To Klee, the choice of formal elements and their mutual relationships is analogous to musical thought. He devotes much time to discussing how the process of creating an image in this way proceeds, and then continues: 'with the gradual growth of such an image before the eyes an association of ideas gradually insinuates itself which may tempt one to a material interpretation. For any image of complex structure can, with some effort of imagination, be compared with familiar pictures from nature.' This is a particular source of misunderstanding with the layman, and danger to the artist if he allows himself to be diverted from the business of composing – building or balancing, to use Klee's terms – his pictures. 'But sooner or later, the association of ideas may of itself occur to the artist . . . Nothing need then prevent him from accepting it, provided that it introduces itself under its proper title.' And having accepted it the artist may well think of additions to enhance the representative element.

Klee was invited to join the Bauhaus at Weimar in November 1920. The Bauhaus, founded in 1919 by Walter Gropius, was the perfect theatre for Klee to unfold his teaching methods. Not an art school in the usual sense, it was devoted to re-uniting the fine and applied arts, and architecture, in a manner suitable for an industrial age. The role of the painters on the staff was not to teach painting but to inculcate an understanding of form. The programme had a sociological bias and a community-based system of instruction, aspects that led the Bauhaus into severe political and internal trouble. In April 1931, two years before it was finally closed by the Nazis, Klee resigned to take up a professorship at the Düsseldorf Academy of Fine Arts. But he held the post for only two years before the Nazi campaign against modern artists brought about his dismissal. Sadly, Klee left Germany to return to Bern, where his father still lived.

Klee's invitation to join the Bauhaus was a kind of fulfilment, and he entered enthusiastically into his work as a pedagogue. He found, like other masters there, that he had to work out a written code of practice as he went on, not only to have a teaching aid but to clear his own mind about procedures that were largely unconscious. He produced in this way an enormous body of didactic writing, little of which was published in his lifetime, but which appeared in two extensive volumes in 1961 and 1973 (English editions). Klee did not think that this exacting preparation for teaching was an interference with his painting. The two things reinforced each other: 'everything must go together or it wouldn't work at all', he wrote.

In his writings and demonstrations, Klee proceeds from first principles to a long analysis of the means available to embody them. In setting out his principles he is concerned not so much with 'art' as with dualism, antithesis, orientation, growth, movement; in other words the basics whereby human beings realize their existence in the world. Klee first had to make his pupils think of their task of form-production in these terms, then re-orient themselves to the world through their exercises.

In practical terms, Klee's pedagogy rested on the belief that 'everything that happens in a picture must have its logical justification'. Faced with the weight of evidence that Klee assembled to make this contention possible, we accept it without demur. Yet it conflicts with nearly everything that the public has been told about the way art and artists work. Where then does the truth lie? It may be said that all

Klee's elaborate teaching had no sequel, did not produce a school of logical painters. Yes, but we have seen that the Bauhaus did not set out to produce *painters*, and Klee's courses certainly helped the Bauhaus to be the immense influence it generally was, in spite of the Nazi years that followed. And since their publication the pedagogic books have been highly valued by logical, numerate artists of the present. On the other hand, unbridled 'intuition' has had a great following among painters, and has produced its flashes of light as well as a great deal of obscurity, but alone it is inadequate for the complex situation of today.

As so often, one must look for a synthesis. Of all artists, Klee is the most *effectively* intuitive, just because by logical thought he was able to refine his means to give instant and accurate form to each intuition. The Bauhaus years were the years of greatest technical variety and invention of form for Klee. There came a time when this great artist had no more need to go on refining his system. Even before giving up teaching he had grown tired elaborating it. From 1933 until his death in 1940 a progressive simplification of his means accompanied a progressively more intense and powerful expression.

A selection of forty-eight plates is certain to miss out works that some people will think the essential Klee, but the works reproduced in this book range from the most abstract to the most figurative, from the architectonic to the poetic, the static to the dynamic. In atmosphere they include the innocent and the highly-charged. The means extend from pure line to the most sophisticated combinations of line, tone and colour and back to simple chromatic grids.

One aspect of the 'essential' Klee will be for some people the fascinating *Twittering Machine* of 1922 (Plate 10). Here the means are economical but sophisticated – a sheet prepared with an old-looking priming of pinkish-grey watercolour, which received an ink line with a rough edge like an etching. Against this worn surface is performed an absurd concert, forcefully suggesting a crazy automaton made of wire with a crank on which four bird-like creatures are mounted. The rise and fall of these piercing creatures is connected, in no very logical way, with the movement of the crank – we see their heads and tongues at various stages of voice-production. Here the thin wavy line and taut structure are perfectly matched to the shrill noise we can expect to hear; also the structure is almost disembodied and floats high above any contact with the ground, indicating that such a high-pitched clamour seems to have little natural reason.

Another 'typical' work by Klee may be for some *A Young Lady's Adventure* of 1921 (Plate 12), which is in the Tate Gallery. Here Klee shows how to combine line and planes of colour in a way essential to his later work. A very free-flowing line spontaneously creates, as it curves and intersects, a whole repertory of interlocking shapes (compare Plate 24). On this foundation is placed a series of delicately graded watercolour washes that establish planes of space and distinguish objects from ground, though not very clearly – the girl's cape and arms merge into the background. The subject is one of the comparatively rare erotic references in Klee, although it is generally taken as playful. A startling red arrow points to the nature of the 'adventure' and the same colour is used for at least one other sexual sign, the extended organ of a little animal in the bottom left corner. Klee had used a 'beast' as a symbol of frustrated male desire in one of his early etchings (Fig. 5), but far more solemnly than this. Perhaps the *Young Lady's Adventure* is an ironic comment from the safety of Klee's maturity on the anxieties of his early youth.

15

Fig. 5
Woman and Beast
1904. Etching,
20 x 22.8 cm.
Paul Klee Foundation,
Kunstmuseum, Bern

Other different uses of line can be seen most notably in Plates 17 to 20, 24 and 25. Compare for example Plates 24 and 25. Both are of the 'walking line' variety – meaning not just that the line is continuous but that it obeys its own compulsion, producing form virtually as a by-product. *Little Jester in a Trance* is drawn with almost a single line, and a set of line monoprints of two years before show this line unadorned, coming close to the idea of 'automatic' drawing put forward by the Surrealists a year or two earlier. In the sheet illustrated Klee tidies up the intersections, adds the eyeball; and by adding tones within the intersected lines he introduces a cubist-like pseudo-modelling, a shallow penetration of the surface, with jagged edges suggesting the clothes of the Jester.

Threatening Snowstorm has lines keeping company and passing right across the field. As these lines only travel in the horizontal and vertical dimension, we form the idea of buildings, and so we see a town under a heavy winter sky, rendered in Klee's spray technique. Klee uses the same convention to convey towns and habitations on other occasions.

With *Carnival in the Mountains* of 1924 (Plate 17) we are in a different world of line. The teachable structure of his work has fallen into the background and Klee's Gothic imagination, prominent in the early etchings, has re-asserted itself. Line is not used here for structural clarity but to create by cross-hatching a smoky, obscure space peopled

by sinister beings. Note that Klee's use of hatching is mainly (to use his teaching vocabulary again) exotopic and not endotopic – that is, the hatching and modelling define the background and not the objects on it, underlining their non-substantive nature. Klee seldom gave such detailed expression to grim fantasy in his middle life. The blind girl and child, the monster holding an eye, are like a Gothic equivalent of Picasso's more famous *Minotaur* etchings in the thirties. *Botanical Theatre* (Plate 18) is an even more elaborate example of the 'exotopic' use of hatched line, to more fanciful and less highly-charged effect. This must count as one of the most highly developed works in Klee's whole output, and he worked at it, unusually, over a period of ten years.

Still another use of line is seen in a number of works such as *Castle to be Built in a Forest* of 1926 and *Pastorale* of 1927 (Plates 20 and 19). Here we are back with more 'teachable' matters, meaning that the effects are capable of analysis. The sequence ending in *Pastorale* begins with some drawings in ink on damp paper, similarly set out in a rhythmical, musical way. These works may be too easily dismissed as 'pattern'. They certainly employ repetition, but always with variety of detail – as in music. The musical analogy extends to a marked resemblance to musical scores. An important part of Klee's teaching dealt with the rhythm of structures. The whole course of his work led to the invention and refinement of pictorial *signs* which he used to obtain the most amazing para-human figuration and emotional expression. The fruits of this development were at their finest in his late period. Meanwhile here in these 'patterned' works structure, rhythm and sign join in a richly varied embroidery, capable of suggesting many parallel meanings. Klee's titles for these works often have botanical references, such as *Ripe Harvest* or simply *Horticulture*. This need not surprise us, as variety within repetition is characteristic of nature and of gardens. Sometimes, by a slight alteration of the sign-language, Klee suggests the presence of streets and buildings alternating with planting. *Pastorale* has a very built-up texture into which the lace-like lines are indented, so that the whole work takes on a tactile and mysterious quality, like an ancient tablet with some runic message on it.

These drawn works lead straight to a group of brush paintings as delightful as any Klee ever did. In the brush paintings, the parallel lines become strokes of the brush, uniting line and colour. Nature is no longer petrified, but intensely luminous, as Klee deploys the colour against a dark ground. *Gate in the Garden* (Plate 21) also looks forward to the late works psychologically, since the gateway, the red rectangle in the upper left corner, resembles the symbols of life and death found in them.

We have not considered these works in strict chronological order. That does not mean there was not an underlying evolution. The trend was always in the direction of economy of means, fewer purely pictorial details, less dynamism. This tendency already appears in the abstract paintings from 1921 (Plates 14 and 15). These, in their rhythmic variety, are far from the rigidity implied by the word 'grid'. They lead one directly to a series, apparently abstract too, which is connected with Klee's short visit to upper Egypt in the winter of 1928-29 (Plates 26 and 27). These are based not on a grid but on a series of horizontal layers, which Klee called strata. The strata are joined, articulated and divided in the same musical way as *Pastorale* is, but do not bear a load of signs. Instead, they are given a solid substance appropriate to the new geological and topographical meaning Klee wanted them to convey. *Monument in Fertile Country* (Plate 26) is the most directly related to upper Egypt. The landscape of that country is the most clearly struc-

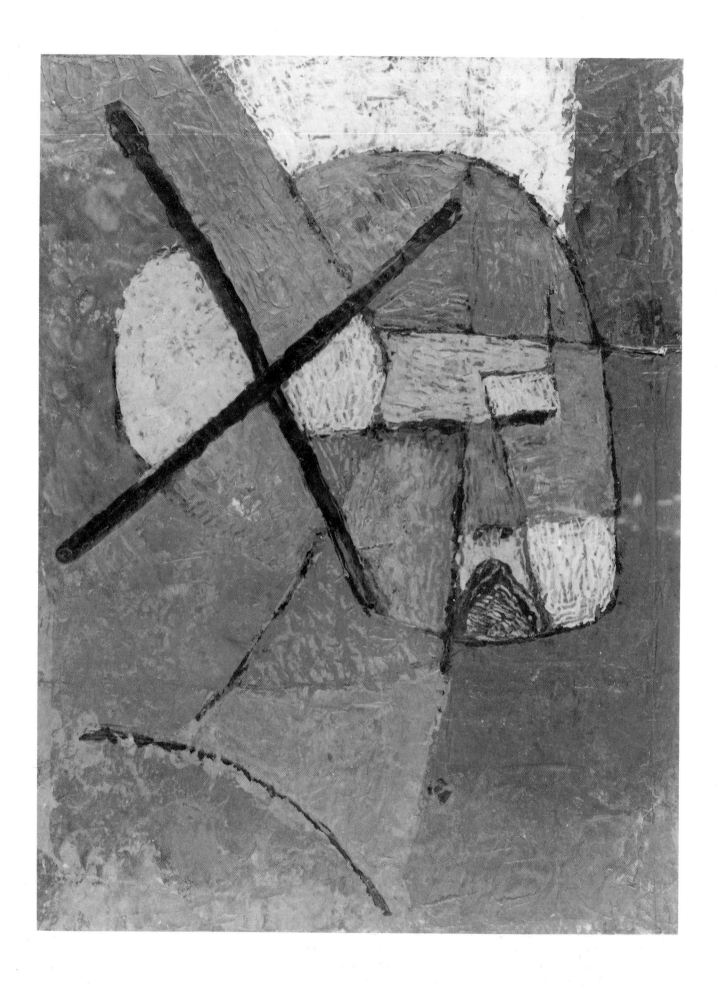

tured imaginable. The great artery of the Nile is flanked on each side by a narrow band of fertile land sharply defined by irrigation ditches at right angles to the river. Beyond a further band of half-desert an austere escarpment of naked rock rises. Into this landscape are fitted the immense stone monuments of ancient Egypt. Klee's painting is an exact analogue of this scene and echoes its clarity. On the left and right we see the cultivated strips, some with crops, some fallow. In the middle, larger units of pink and sandy colour denote the huge blocks of temple or colossus. Some diagonal lines suggest an element of space in what would otherwise be a map-like representation. Egyptian influence of a different kind may be seen in *Ad Marginem* (Plate 28), where among Klee's personal sign-objects disposed around the four edges of the work stands a wading bird straight from Egyptian painting. The huge sun-disc moreover and some of the signs themselves suggest a similar origin. This work is an interesting example of centrifugal composition and illustrates Klee's liking for edges and his idea of all-round orientation; the work is an object independent of direction or of the wall, as if it were a ceiling painting or a mosaic on the floor.

That these 'Egyptian' works foreshadow the last phase is not disproved by the existence of contemporary or later works such as Plate 30, which seem still to belong to the world of Bauhaus instruction. The same reductive tendencies are at work on them too. The unusually large painting *Ad Parnassum* (Plate 34), painted in Klee's Düsseldorf years, is truly transitional between the Bauhaus and the late period, although it may well show an Egyptian image. This belongs to a group in which Klee employs spots of colour in a way akin to mosaic. Klee had visited Ravenna in 1926 to see the mosaics, but the idea of building up a picture from very small units was already consistent with his thinking. In some of this group the spots are indeed square and close together, but in *Ad Parnassum* they are more rounded, and show some of the ground between them. There is a somewhat impersonal grandeur, rare in Klee, about this canvas and also the wholly abstract canvas *Polyphony* (Plate 33), executed in the same technique. These and a few others are culminations in every sense – fruits of long technical preparation and intensive thought especially on the musical qualities of painting; coming at the end of a distinguished career of teaching and painting, which had brought him extensive fame. The intense individuality of Klee which makes him so much *sui generis* that his work will not hang easily with others is temporarily reduced in the early thirties, only to reappear again with retirement and illness. Helped by their larger size, these works would appear as key works in any museum of modern art that was fortunate enough to possess them, effortlessly surpassing the noisier and often much more recent works of other artists in the same vein.

Klee was dismissed from his teaching post at the Düsseldorf Academy in 1933. In that year he produced a very private painting which remained in his possession till his death – *Struck from the List* (Fig. 6). Although there are compositional precedents for such a work, its autobiographical character is plain, and it bears an uncanny resemblance to a photograph of Klee taken the same year (Fig. 7). In December 1933 he returned to Bern and to a simple, disciplined and very private existence, such as he had always preferred. In the summer of 1935 the symptoms of his fatal illness appeared. Its ravages can be seen in the photographs taken in the following years (Fig. 8) but, except in 1936, he continued productive to the end, which came in June 1940.

Dismissed from public life and from the country he regarded as his own, depressed by the Nazi tyranny which pilloried him as 'degener-

Fig. 6
Struck from the List
1933. Oil on waxed paper,
31.5 x 24 cm.
Private collection, Bern

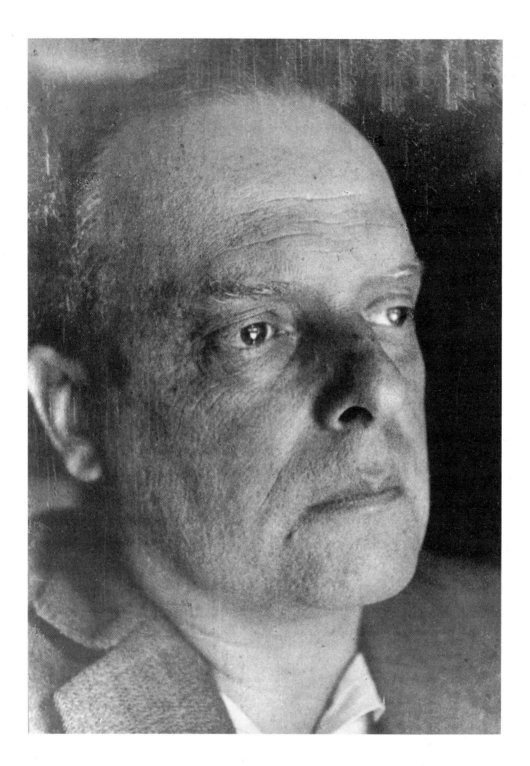

Fig. 7
Photograph of Paul
Klee, Dessau 1933

Fig. 8
Photograph of Paul
Klee, Bern 1939

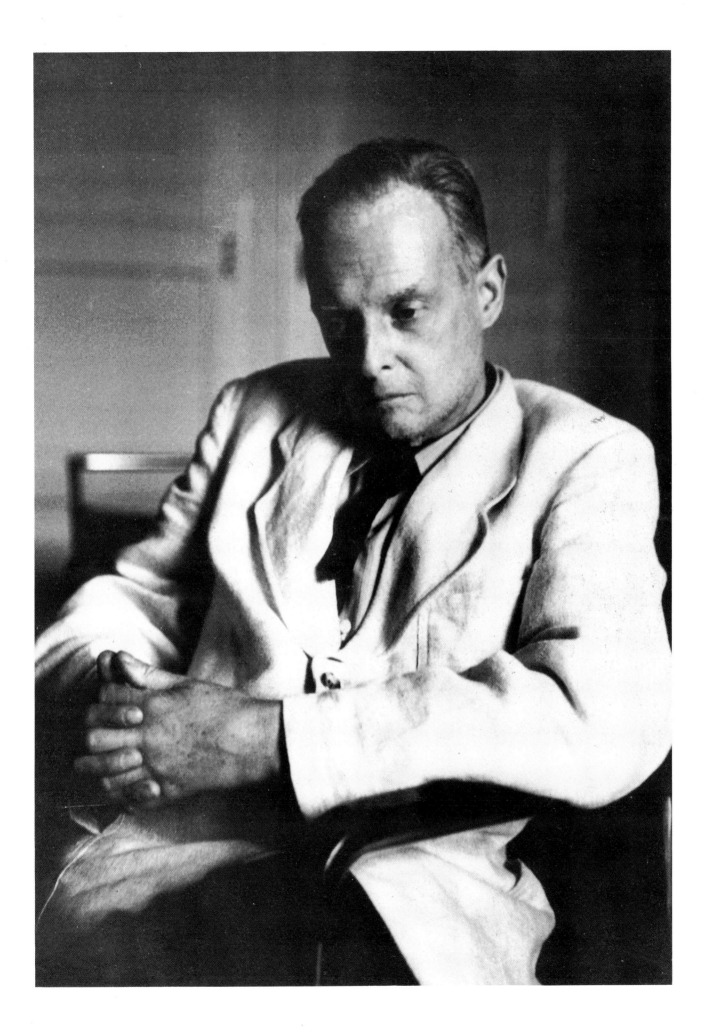

Fig. 9
Hold Out!
1940. Black chalk on
drafting paper,
29.6 x 20.9 cm.
Paul Klee Foundation,
Kunstmuseum, Bern

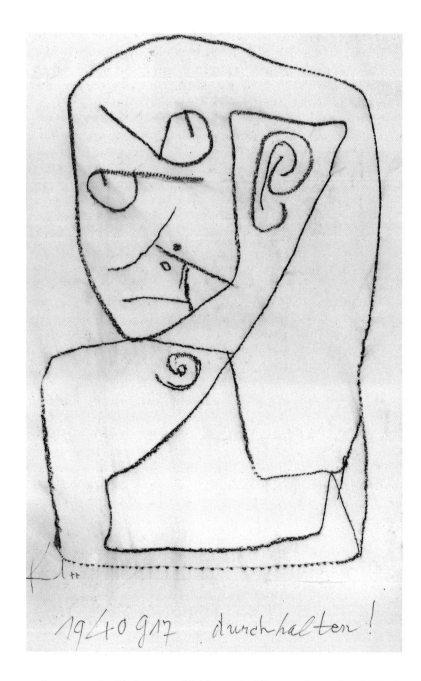

ate', constantly ill, how could his work fail to reflect all this? It is remarkable that Klee never lost his puckish humour, which was a necessary ingredient in his expressionism. It is expressed even in the poignant drawings of the last months, such as *Durchhalten!*, which may be translated as *Hold Out!* or *Keep Going!* (Fig. 9). But his true late period, which runs from 1935 to 1940, is marked by great changes.

These changes can be considered under technique, composition and expression. Greater simplicity marks the two first; greater intensity the third. Line drawing, of course, continued all the time. Alongside it a method of drawing with the brush developed, a thick brush whose heavy emphasis needed the crispest and most assured handling and far exceeded the later work of the abstract expressionists in its capacity to reveal the artist's mind and soul. This method embraced both painting and drawing and came to a peak in 1939 and 1940 (Plates 47 and 48). Klee's liking for coarse canvas became stronger, and in the last works colour seems rubbed in, rather than painted on this canvas, giving an effect both dry and compelling in conjunction with a great black line (Plate 45). Other technical effects at this time are directed to rough,

primitive appearances. A good part of this evolution can be attributed to his illness and declining physical strength and energy.

The overriding change in Klee's late method of composition was the breaking down of his former flowing line and rhythmic repetitions into separate units. The peak of the 'disjunctive' method of composing comes in several paintings of 1938 (Plates 42 and 43). These lovely works come before the final, grim outpouring of images when Klee knew that he was dying, therefore they have the strength and the quality of surprise imparted by the late style, without its greatest asperities. *Red Waistcoat* (Plate 42) still has much of the charm of earlier years as well. The broken line of late Klee, resulting in the distribution of 'signs' or ideograms over the whole picture field, is one of the few new inventions since cubism – from which, indeed, Klee may have partly derived it. It is a development of the cubists' idea that paintings do not serve to locate images in space but to suggest relationships. Klee's fragments of discontinuous line cannot possibly be used to locate images, but they cause the whole picture field to come alive with possible relationships. The notion of location has been replaced by that of *interval*, which exists all over the field as a power of attraction or repulsion. In Plates 42 and 43 there is no dominant feature, no hierarchy within the picture, which is presented as a totality.

It is difficult to be dispassionate about the composition or technique of Plates 47 and 48 when they are so obviously the expression of emotion in the face of impending death. These are the final culmination, and they come at the end of a period when Klee's titles more and more direct the viewer to numinous experiences, malign forces and the human beings who are their instrument. The discontinuous style was uniquely suited to convey these, although we saw above that it need not do so.

The work of Paul Klee, of all periods but especially the last, has been of enormous importance in the development of modern art. Its effect was delayed by Facism in Germany and perhaps by a lack of acceptance in France, but since the last war it has been constantly increasing. Klee had at his command a greater variety of formal invention than any other modern master. Almost alone he never succumbed to pressure to repeat himself or to the forces that make for decline in famous artists. His whole late work was a manifesto and act of bravery, for it was far less easily acceptable than what had gone before. Above all it is by his intellectual capacity that Klee dominates his contemporaries, none of whom, not even Kandinsky, could think through the full implications of what they were doing as he could. Many talked about a new relationship between art and nature; only Klee actually tried to define it, and with considerable success. At a time of uncertainty and loss of direction in art he is a source of confidence and admiration.

Outline Biography

1879	Born in December at Munchenbuchsee near Bern, son of music teacher Hans Klee and Ida Maria Frick.
1898	Graduates from *Literarschule*, Bern.
1989-1901	First Munich period. Studies first at the private art school of Erwin Knirr, then at the Academy of Fine Art.
1901-02	Travels in Italy.
1906	Marriage to Lily Stumpf. Second Munich period until 1916.
1910	Exhibition in three Swiss cities.
1911	First one-man exhibition in Munich. Klee begins the catalogue of his work, retrospective to 1883.
1914	Visit to Tunisia, April.
1916-18	Service with the German Army.
1921	Joins the Bauhaus in Weimar.
1923	First pedagogic work published in the *Bauhaus-Buch*.
1924	First exhibition of Klee in U. S. A.
1925	Bauhaus moves to Dessau.
1931	Appointed to the Düsseldorf Academy of Fine Art with effect from 1 April.
1933	Dismissed from Academy under Nazi pressure. Settles in Bern again.
1934	First Klee exhibition in Britain.
1935	First symptoms of his fatal illness (later diagnosed as sclerodermia). Large exhibition at Bern and Basel.
1937	Klee's work confiscated from German museums and included in 'Degenerate Art' exhibition in Munich.
1940	Death of Klee at Muralto-Locarno, 29 June.

Select Bibliography

Since this book first appeared in 1977 the literature on Klee has increased enormously. Three works in particular have enlarged the understanding of Klee for readers of English and are added below to three classics in translation that are widely available in libraries. The definitive publications of the Bern Kunstmuseum now stand at three volumes. There has also been a series of important exhibitions since 1979, the centenary of Klee's birth.

Monographs

W Grohmann: *Paul Klee*, 1954. Still the most comprehensive work, by an author who knew Klee well and first wrote about him in 1924.

W Haftmann: *The Mind and Work of Paul Klee*, 1954 and 1967.

C Geelharr: *Paul Klee and the Bauhaus*, 1973. *Paul Klee: Life and work*, 1982

Margaret Plant: *Paul Klee: Figures and Faces*, London 1978

Andrew Kagan: *Paul Klee / Art and Music*, 1983

Richard Verdi: *Klee and Nature*, 1984

Permanent Collection Catalogues

The works by Klee in the Kunstmuseum, Bern are being catalogued in four volumes. The following have appeared:

1. *Gemalde, Farbige Blatter, Hinterglasbilder und Plastiken*
2. *Handzeichnungen I, Kindheit bis 1920*
3. *Handzeichnungen II*

Exhibition Catalogues

Munich, Lenbachhaus, 1970-80: *Klee, 1883-92*
Cologne, Museum Ludwig, 1979: *Klee, 1919-1933*
New York, Museum of Modern Art, Cleveland and Bern, 1987-88: *Klee*

List of Illustrations

Colour Plates

1. The Artist at the Window
 1909. Ink, wash and coloured chalk, 29.8 x 24.7 cm.
 Private Collection, Switzerland

2. Red and White Domes
 1914. Watercolour and body-colour, 14.6 x 13.7 cm.
 Kunstsammlung Nordrhein-Westfalen, Düsseldorf

3. On a Motif from Hamamet
 1914. Tempera on board, 27 x 22.5 cm.
 Kunstmuseum, Basel

4. Hermitage
 1918. Watercolour on chalk ground, 18.3 x 25.4 cm.
 Paul Klee Foundation, Kunstmuseum, Bern

5. Growth in an Old Garden
 1919. Watercolour and coloured chalks on
 paper, 15 x 21cm. Formerly Fischer Fine Art Ltd.,
 London

6. Cosmic Composition
 1919. Oil on pasteboard, 48 x 41 cm.
 Kunstsammlung Nordrhein-Westfalen, Düsseldorf

7. Nocturnal Festivity
 1921. Oil on board, 50 x 61 cm.
 Solomon R. Guggenheim Museum
 (Robert E. Mates and Mary Donlon Collection),
 New York

8. Red Balloon
 1922. Oil on muslin primed with chalk,
 31.8 x 31.1 cm. Solomon R. Guggenheim Museum,
 New York

9. Senecio
 1922. Oil on gauze, 40.5 x 38 cm.
 Kunstmuseum, Basel

10. Twittering Machine
 1922. Watercolour and oil drawing, 40.6 x 29.8 cm.
 Museum of Modern Art, New York

11. The Tightrope Walker
 1923. Lithograph, 43.2 x 26.7 cm.
 Scottish National Gallery of Modern Art, Edinburgh

12. A Young Lady's Adventure
 1921. Watercolour, 43.8 x 30.8 cm.
 Tate Gallery, London

13. Puppet Theatre
 1923. Watercolour on chalk ground, 51.4 x 37.2 cm.
 Paul Klee Foundation, Kunstmuseum, Bern

14. Crystal Gradation
 1921. Watercolour, 24.5 x 31.5 cm.
 Kunstmuseum (Kupferstichkabinett), Basel

15. Fugue in Red
 1921. Watercolour, 23.9 x 33 cm.
 Private Collection, Switzerland

16. Reconstruction
 1926. Oil on muslin, 36.3 x 39.3 cm.
 Kunstsammlung Nordrhein-Westfalen, Düsseldorf

17. Carnival in the Mountains
 1924. Watercolour on paper on board, 23.5 x 31.1 cm.
 Paul Klee Foundation, Kunstmuseum, Bern

18. Botanical Theatre
 1924/34. Oil and watercolour on board,
 50.2 x 67.2 cm. Private Collection, Bern

19. Pastorale
 1927. Tempera on canvas on wood, 69.2 x 51.7 cm.
 Museum of Modern Art (Abby Aldrich Rockefeller
 Fund), New York

20. Castle to be built in the Forest
 1926. Watercolour, 26.7 x 39.5 cm.
 Private Collection

21. Gate in the Garden
 1926. Oil on panel, 54.5 x 44 cm.
 Huggler Foundation, Kunstmuseum, Bern

22. Fish Magic
 1925. Oil and watercolour varnished, 76.8 x 98.1 cm.
 Museum of Art (Louise and Walter Arensberg
 Collection), Philadelphia

23. Around the Fish
 1926. Tempera and oil, 46.3 x 64.1 cm.
 Museum of Modern Art (Abby Aldrich Rockefeller
 Fund), New York

24. Threatening Snowstorm
 1927. Pen and ink and watercolour sprayed,
 48.9 x 31.4cm. Scottish National Gallery of Modern
 Art, Edinburgh

25. Little Jester in a Trance
 1929. Oil and watercolour on hessian, 50 x 35.5 cm.
 Museum Ludwig, Cologne

26. Monument in Fertile Country
 1929. Watercolour, 46 x 30.5 cm.
 Paul Klee Foundation, Kunstmuseum, Bern

27. Fire in the Evening
 1929. Oil on board, 37 x 36 cm.
 Museum of Modern Art (Mr and Mrs Joachim Jean
 Aberbach Fund), New York

28. Ad Marginem
 1930. Watercolour varnished, 46.3 x 35.9 cm.
 Kunstmuseum, Basel

29. Fruits on Red
 1930. Watercolour on silk, 61.2 x 46.2 cm.
 Stadtische Galerie im Lenbachhaus, Munich

30. Conqueror
 1930. Watercolour, 41.6 x 34.2 cm.
 Paul Klee Foundation, Kunstmuseum, Bern

31. Three Subjects, Polyphony
 1931. Watercolour and pencil, 48 x 63 cm.
 Formerly Fischer Fine Art Ltd., London

32. Uplift and Direction (Glider Flight)
 1932. Oil on canvas, 90 x 91 cm.
 Sold Christie's, London, April 1989

33. Polyphony
 1932. Tempera on linen, 66.5 x 106 cm.
 Emmanuel Hoffman Foundation,
 Kunstmuseum, Basel

34. Ad Parnassum
 1932. Oil on panel, 100 x 126 cm.
 Paul Klee Foundation, Kunstmuseum, Bern

35. The Future Man
 1933. Watercolour applied by spatula, 61.8 x 46 cm.
 Paul Klee Foundation, Kunstmuseum, Bern

36. Blossoming
 1934. Oil on board, 81.9 x 81.3 cm.
 Kunstmuseum, Winterthur

37. Drawn One
 1935. Gauze, 30.5 x 27.5 cm.
 Kunstsammlung Nordrhein-Westfalen, Düsseldorf

38. Walpurgis Night
 1935. Gouache on fabric, 50.8 x 47cm.
 Tate Gallery, London

39. Jewels
 1937. Pastel on cotton, mounted on canvas,
 57 x 76 cm. Kunstsammlung Nordrhein-Westfalen,
 Düsseldorf

40. Contemplating
 1938. Paste colour on newsprint, 47.2 x 65.8 cm.
 Galerie Beyeler, Basel

41. Heroic Roses
 1938. Oil on stained canvas, 68 x 52 cm.
 Kunstsammlung Nordrhein-Westfalen, Düsseldorf

42. Red Waistcoat
 1938. Paste colour, waxed, 65.1 x 42.5 cm.
 Kunstsammlung Nordrhein-Westfalen, Düsseldorf

43. Park near Lu(cerne)
 1938. Oil on panel, 100 x 70.2 cm.
 Paul Klee Foundation, Kunstmuseum, Bern

44. Outburst of Fear
 1939. Watercolour on paper prepared with tempera,
 63 x 48 cm. Paul Klee Foundation, Kunstmuseum,
 Bern

45. Mephisto as Pallas
 1939. Tempera and watercolour on black prepared
 paper, 90.5 x 150 cm. Ulmer Museum, Ulm

46. Woman in Peasant Dress
 1940. Paste colour on paper, 48 x 31.7 cm.
 Paul Klee Foundation, Kunstmuseum, Bern

47. Kettledrummer
 1940. Paste colour on paper, 34.4 x 21.7 cm.
 Paul Klee Foundation, Kunstmuseum, Bern

48. Death and Fire
 1940. Oil on panel, 46 x 44.1 cm.
 Paul Klee Foundation, Kunstmuseum, Bern

Text Figures

1. Photograph of Paul Klee, Bern 1906

2. Photograph of Lily Stumpf, later Klee, Bern 1903

3. Paul Klee's studio in Munich, 1920

4. Virgin in a Tree
 1903. Etching, 28.7 x 29.7 cm.
 Paul Klee Foundation, Kunstmuseum, Bern

5. Woman and Beast
 1904. Etching, 20 x 22.8 cm.
 Paul Klee Foundation, Kunstmuseum, Bern

6. Struck from the List
 1933. Oil on waxed paper, 31.5 x 24 cm.
 Private Collection, Bern

7. Photograph of Paul Klee, Dessau 1933

8. Photograph of Paul Klee, Bern 1939

9. Hold Out!
 1940. Black chalk on drafting paper,
 29.6 x 20.9 cm.
 Paul Klee Foundation, Kunstmuseum, Bern

Comparative Figures

10. Robert Delaunay: Fensterbild
1912/13. Kunstsammlung Nordrhein-Westfalen,
Düsseldorf

11. Homage to Picasso
1914. Oil on board, 34.9 x 29.2 cm.
Private Collection, Connecticut

12. Gontcharova: Backdrop design for
'The Golden Cockerel'
1914. Gouache, watercolour and pencil on card-
board, 47.3 x 61.6 cm. Museum of Modern Art, New
York (acquired through the Lillie P. Bliss Request)

13. Composition with Windows (with a B)
1919. Paul Klee Foundation, Kunstmuseum, Bern

14. Photograph of Felix Klee's puppet
theatre, 1922

15. Villa R
1919. Oil on board, 26.5 x 22 cm.
Kunstmuseum, Basel

16. Sonia Delaunay: Prismes Electriques
1914. Oil on canvas, 250 x 250 cm.
Musée National d'Art Moderne, Paris

17. The Matter, Spirit and Symbol of Attack
1922. Watercolour and oil on paper, 33.5 x 47.5 cm.
Lady Hulton Collection, London

18. Battle Scene from 'The Navigator'
1921. Private Collection, Basel

19. Eros
1923. Watercolour, 33.3 x 24.5 cm.
Rosengart Collection, Lucerne

20. Picasso: Minotauromachia
1935. Etching and drypoint, 49.8 x 69.3 cm.
Musée Picasso, Paris

21. Magic Theatre
1923. Pen and brush and Indian ink, with
watercolour, 33.6 x 22.8 cm.
Paul Klee Foundation, Kunstmuseum, Bern

22. Garden for Orpheus
1926. Pen and Indian ink on paper,
mounted on board, 47 x 32.5 cm.
Paul Klee Foundation, Kunstmuseum, Bern

23. View of G (Partie aus G)
1927. New York

24. Highway and Byways
1929. Museum Ludwig, Cologne

25. In the Current, Six Thresholds
1929. Solomon R. Guggenheim Museum, New York

26. Daringly Poised
1930. Watercolour and Indian ink on paper,
mounted on board, 31 x 24.6 cm.
Paul Klee Foundation, Kunstmuseum, Bern

27. Dynamic – Polyphonic Group
1931. 31.5 x 48 cm.
Private Collection, Switzerland

28. The Niesen
1915. Private Collection, Bern

29. Stage Landscape
1937. Private Collection, Bern

30. Braque: Bottle and Glass
1912. 55 x 38 cm. Private Collection, Bern

31. Revolution of the Viaduct
1937. Kunsthalle, Hamburg

32. A Face, also of the Body
1939. Private Collection, Switzerland

The Plates

The Artist at the Window

1909. Ink, wash and coloured chalk, 29.8 x 24.7 cm. Private Collection, Switzerland

All Klee's work is permeated by self-portraiture. In the later periods the image is often disguised, but there are numerous plainly self-portrait drawings between 1899 and 1919. In these, the artist interrogates himself and his state of mind through eyes that are wary or troubled. Here, however, the face is in shadow, and only the hunched posture, distorted as it is, suggests introspective concentration on the sheet before him. It is the early Klee that we see here, full of self-doubt about himself and art, not yet the master of colour and the inspiring teacher he later became. Perhaps the most interesting thing about this watercolour is the way in which Klee interpreted the painters of the modern French school, such as Matisse, by greatly exaggerating the distortions they employed.

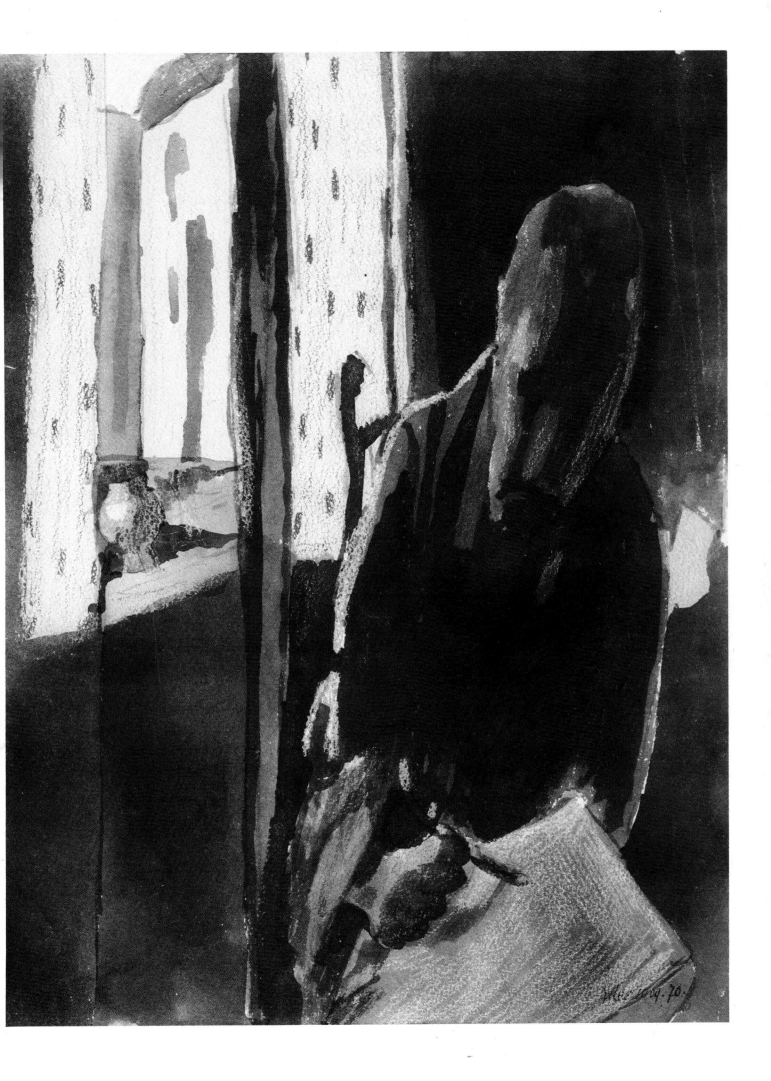

Red and White Domes

1914. Watercolour and body-colour, 14.6 x 13.7 cm. Kunstsammlung Nordrhein-Westfalen, Düsseldorf

Fig. 10
**Robert Delaunay:
Fensterbild**

1912/13. Kunstsammlung
Nordrhein-Westfalen,
Düsseldorf

The paintings inspired by Klee's visit to North Africa in the spring of 1914 fully justify his ecstatic declaration quoted at the beginning of this book: 'I am a painter!' They demonstrate that Klee's idea of painting was already an essentially modern one. The many European painters who had travelled to North Africa in the previous century had seen themselves mainly as chroniclers of a fierce and romantic life, to be captured on canvas with all the skill their western narrative technique could command. Klee had already decided that painting is made from paint, not from narrative, and that colours are to painters what sounds are to musicians. 'Colour and I are one', he wrote. Klee was also responsive to the local colour and the North African style of building based on the cube and the dome. All this is integrated into the picture here, as effectively as Robert Delaunay integrated the Paris roofscape and the outline of the Eiffel Tower into his series of paintings called *Windows* (Fig. 10). Klee had met Delaunay in 1912 and evidently found his brand of Cubism more congenial than that of Braque and Picasso.

Klee

Rote u. weisse Kuppeln 1914. 45.

3 On a Motif from Hamamet

1914. Tempera on board, 27 x 22.5 cm. Kunstmuseum, Basel

Fig. 11
Homage to Picasso

1914. Oil on board,
34.9 x 29.2 cm.
Private Collection,
Connecticut

Although it is directly based on the experience of a particular place, like *Red and White Domes* (Plate 2), Plate 3 comes closer to Delaunay's more abstracted vision. However a watercolour of the same composition in the Kunstmuseum, Basel, places it securely in a landscape context. Not even Delaunay's *Windows* (Fig. 10) emphasize the grid construction as Klee does here, although Klee breaks it with a fanciful shape at the bottom – a tree or bush on a hill perhaps? He continued to use this combination of the structural grid with intuitive detail throughout his life. By contrast, the analytical Cubism of Braque and Picasso avoids an obvious grid structure. So it is strange to find Klee dedicating one of his most grid-like paintings of this time to Picasso (Fig. 11). He was clearly intrigued by the oval formats employed by both Picasso and Braque, but at this stage may not have understood their purpose, so that his own near-oval shape is imposed on his composition instead of complementing it.

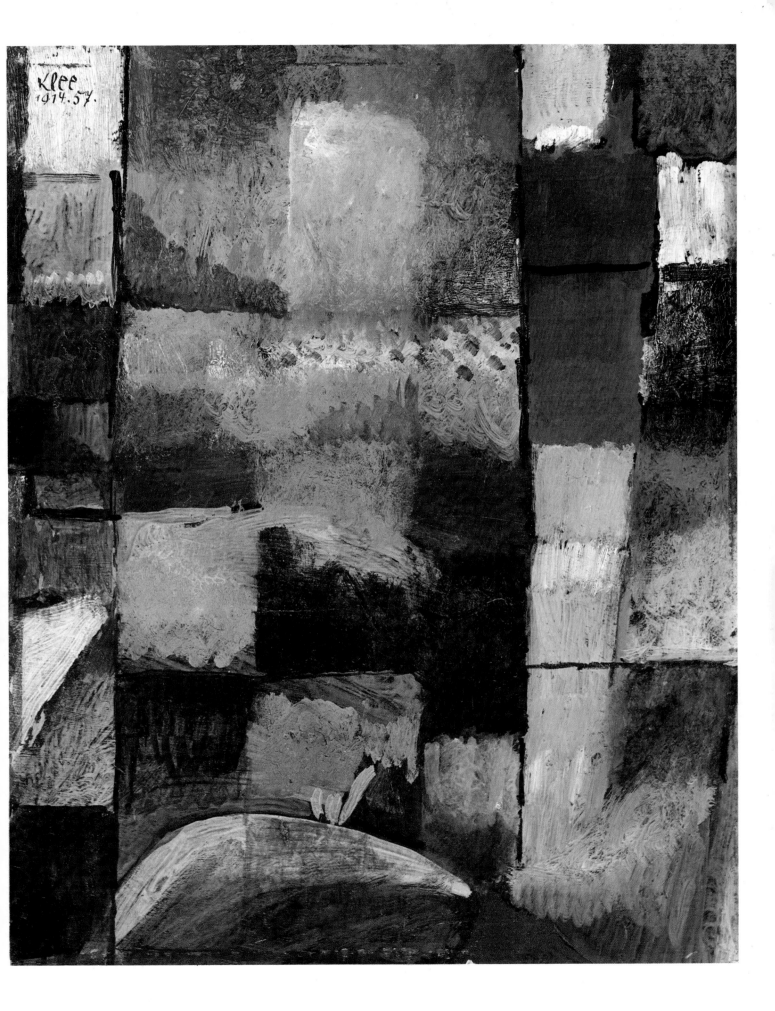

1918. Watercolour on chalk ground, 18.3 x 25.4 cm. Paul Klee Foundation, Kunst-museum, Bern

Fig. 12
Gontcharova:
Backdrop design
for 'The Golden
Cockerel'

1914. Gouache,
watercolour and pencil on
cardboard, 47.3 x 61.6 cm.
Museum of Modern Art,
New York (acquired
through the Lillie P. Bliss
Request)

For some artists, Cubism was a path to a total abstraction that met their spiritual need. Klee was not among them. The musical faculty that encouraged abstraction was constantly held in check by a love of theatre which required a sense of place to be conveyed. Music and theatre join in opera, and one recent writer has been led to describe much of Klee's work as operatic. *Hermitage* directly invokes a stage by including the folds of a curtain on each side. It could be a sketch for a theatre back-cloth, and stands comparison with those produced for Diaghilev's Russian Ballet (Fig. 12). Since the French-inspired paintings of 1914 such as Plates 2 and 3, Klee's fatherland had been at war with France. Though he was no chauvinist or warmonger, it is nevertheless not surprising that Klee felt remote from Paris in 1918. The affinity of *Hermitage* is now more with a German fairy-tale, in a manner that Klee was to combine, all his life, with an immensely sophisticated range of techniques.

Einsiedelei

1918/61.

5 Growth in an Old Garden

1919. Watercolour and coloured chalks on paper, 15 x 21 cm. Formerly Fischer Fine Art Ltd., London

In the fairy-tale surroundings of *Hermitage* we already see plants and trees, depicted in what seems like a simple shorthand way. *Growth in an Old Garden* continues on the same plane of fancy, but now the vegetation has almost taken over. It is all still represented in a sort of shorthand, but already, in his drawings, Klee was showing a detailed interest in the botanical intricacies of simple plants like the horsetail, which may be speculatively recognized here. The very idea of *growth* was immensely important to Klee and formed a bridge between his botanical and non-botanical work. Nature, to him, meant the laws of growth rather than the aesthetics of landscape or gardening. The notion of a neglected garden invaded by primitive plant growth would have been attractive to him, and he was constantly to revert to the theme of the balance of forces between natural and man-made, and between order or disorder.

Cosmic Composition

1919. Oil on pasteboard, 48 x 41 cm. Kunstsammlung Nordrhein-Westfalen, Düsseldorf

42

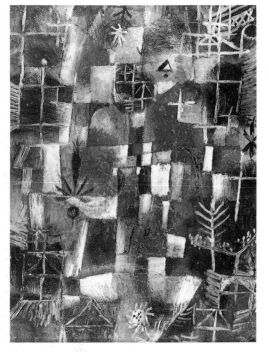

Fig. 13
**Composition with
Windows
(with a B)**

1919. Paul Klee
Foundation,
Kunstmuseum, Bern

Underlying this painting is a grid of soft-edged rectangles of colour, such as are found in the Delaunay-like works of 1914. A fanciful spatial structure is imposed on it by nervous drawing with the brush, showing frames, steps and gangways of the kind that flowed so easily from his pen in numerous drawings of this period. In the upper centre is an occluded sun half obscuring an eye, with the moon and stars. The circle is a potent symbol in art and is used often, but often ambiguously, by Klee. The 'sun' in Plate 5 is perhaps a sunflower, or may stand for the sun as the origin of photosynthetic growth. The title *Cosmic Composition*, on the other hand, suggests that we should recognize here a heavenly body, while the presence of an analogue of the sun, the eye, keeps it on an appropriately symbolic level. Klee would frequently insert items in his works of a different order of reality, like the large capital B in *Composition with Windows* (Fig. 13). This is in other respects a similar work to Plate 6, and it is not known what the initial B stands for, though it may be no more than the initial letter of Klee's home town, Bern.

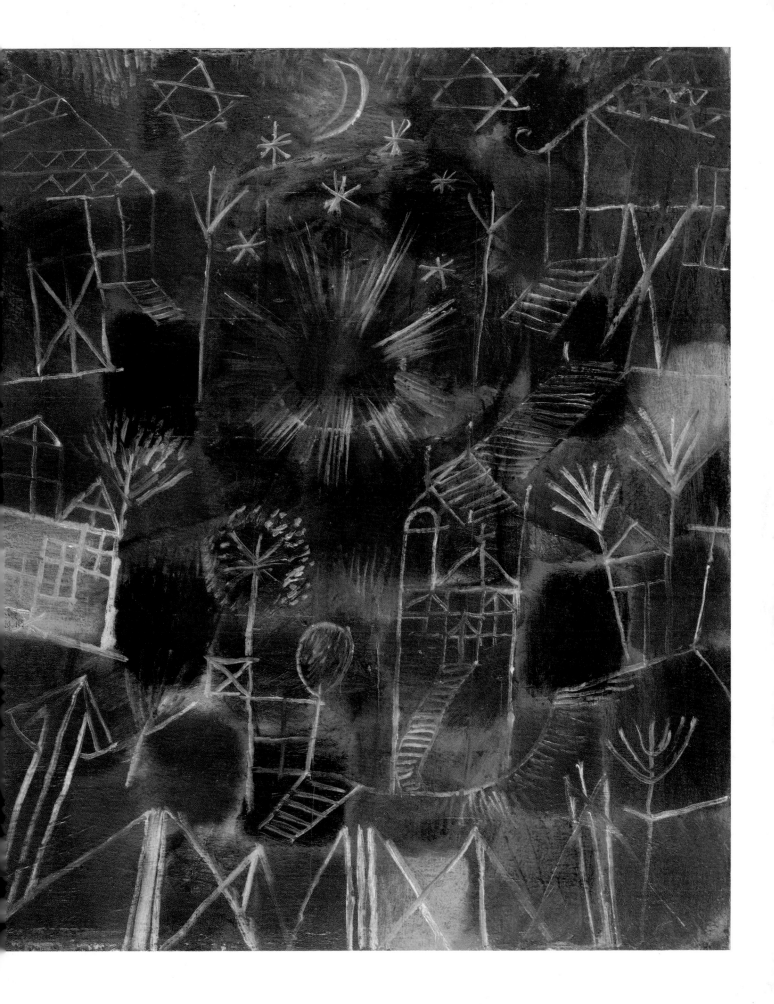

Nocturnal Festivity

1921. Oil on board, 50 x 61 cm. Solomon R. Guggenheim Museum (Robert E. Mates and Mary Donlon Collection), New York

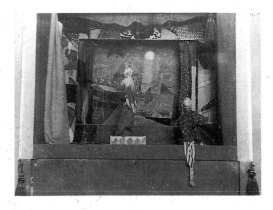

Fig. 14
Photograph
of Felix Klee's
puppet theatre,
1922

Despite the absence of obvious clues like the folds of curtains, this is a work that speaks strongly of the theatre. There are no actors but Klee, as he often does, somehow creates the expectation of their imminent entry. The theatrical impression, as in Plate 4, is partly due to the atmosphere of fairy-tale invoked by the insubstantial buildings and their mysterious lighting. In fact, the connection is more than speculative. It is known that Klee made puppets for his son Felix, who was born in 1907, and some of these survive. Felix was nearly 14 when his father moved to Weimar to teach at the Bauhaus, and it must have been shortly afterwards that Klee made him a theatre in which to perform with them. The theatre itself does not survive, but a photograph shows it with a backcloth of a very similar picto-rial type (Fig. 14). Plate 7 is of compatible size and, being on board, might even have been intended to be inserted at the back of the stage as an alter-native scenario.

Red Balloon

1922. Oil on muslin primed with chalk, 31.8 x 31.1 cm. Solomon R. Guggenheim Museum, New York

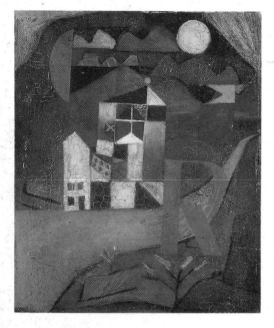

Fig. 15
Villa R

1919. Oil on board,
26.5 x 22 cm.
Kunstmuseum, Basel

To an unusual degree Plate 8 unites the sophistication of contemporary abstraction with the dream-like narrative we expect of Klee. Except the sun/balloon itself and the dome, everything is achieved by straight lines, but there is nothing of the formality of Mondrian or Malevich. The relative informality is due to many features – the delicacy and hesitancy of the lines, the reticent receding colours, as well as the images it is so easy to read into the painting. The straight lines also play an amusing counterpoint with the wavy weave of the muslin on which they are painted. From this time Klee became increasingly interested in the techniques necessary to give his painted works a special aura. He did not aim for a spurious effect of age, but wished the work to have that specially treasured and worked-on feel that is normally reserved for antiquities. The elaborate preparation of Klee's panels was directed to that end and also ensured a high degree of durability. *Villa R* (Fig. 15), a more densely painted oil of three years earlier, seems to have had a less elaborately prepared ground and has suffered a small amount of cracking.

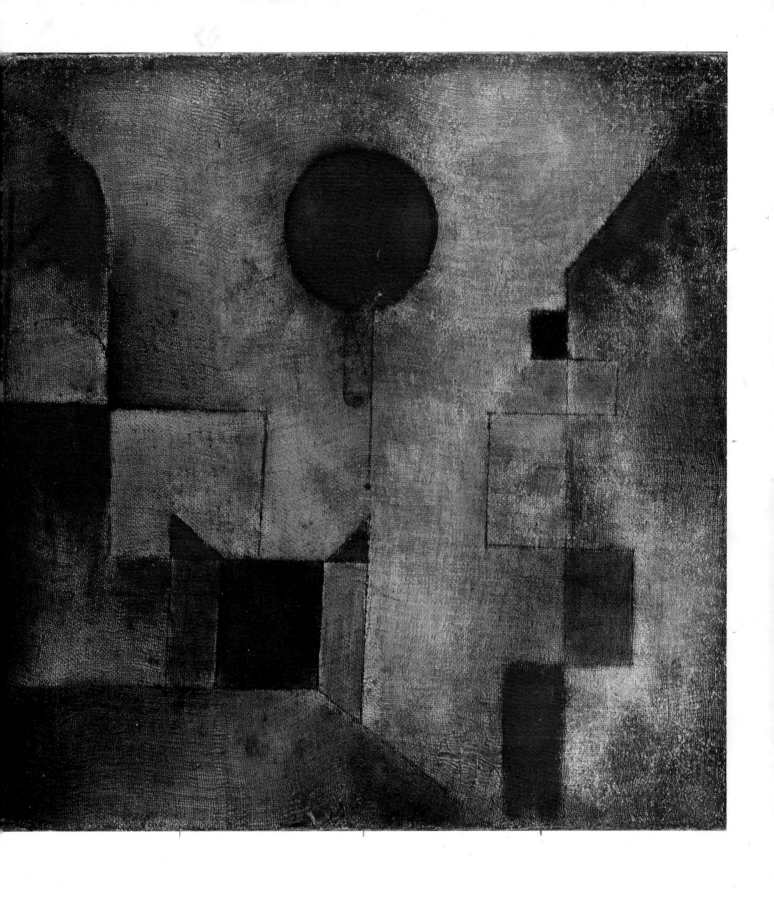

Senecio

1922. Oil on gauze, 40.5 x 38 cm. Kunstmuseum, Basel

Fig. 16
Sonia Delaunay:
Prismes
Electriques

1914. Oil on canvas,
250 x 250 cm.
Musée National d'Art
Moderne, Paris

On a formal level, Klee's attempt to reconcile the square and the circle in this picture still connects him with Robert Delaunay and his wife Sonia. The Delaunays became progressively more interested in the radiating circle as a symbol of energy, as the title of Fig. 16 conveys. With his own interest in the energy inherent in the growth of plants, Klee has put the circle to a somewhat different application here, to denote the form of a flower. That much is certain from his choice of title for the painting, *Senecio* being the botanical name for a genus of plants including the common ragwort as well as various garden plants with round flower-heads. The yellow colour as of ragwort, the eyes as radiating petals, support the identification of the title. Richard Verdi, who assumes that the face depicted is that of a child, suggests that Klee was drawing a parallel between the flower as the crowning glory of the plant, and the human face as the flower of the body. Plate 9 is among the most superficially child-like of Klee's paintings, but on long contemplation its tones shift and merge until it becomes an icon of almost hypnotic power. Other interpretations are also possible. The name *Senecio* suggests the Latin *senex*, old man. Did Klee intend a paradox on the theme of youth and age?

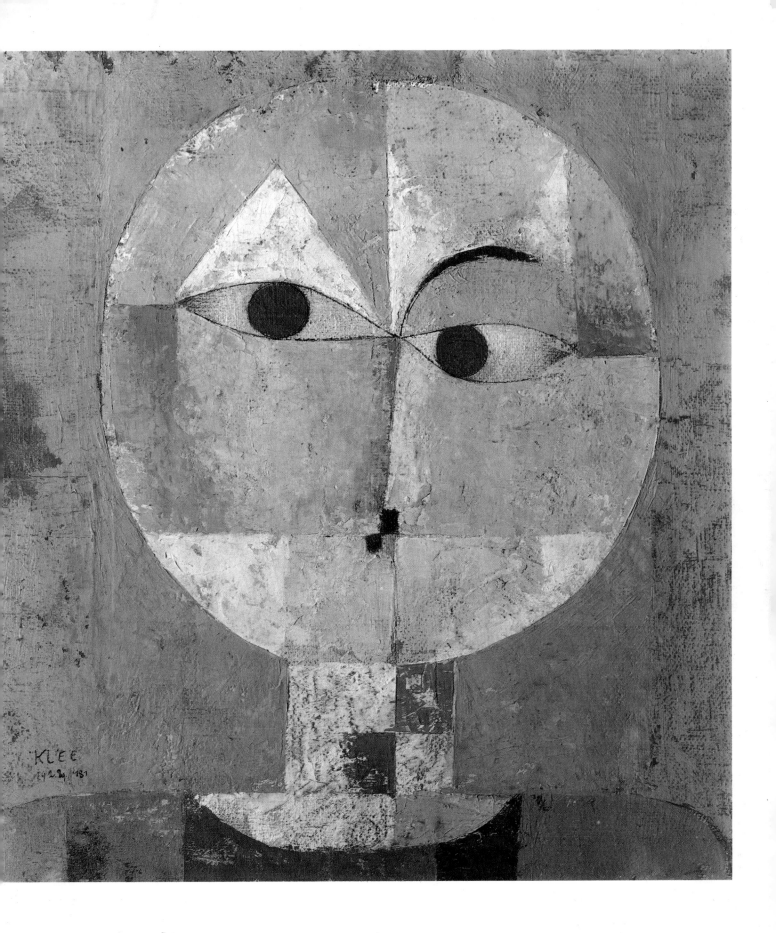

1922. Watercolour and oil drawing, 40.6 x 29.8 cm. Museum of Modern Art, New York

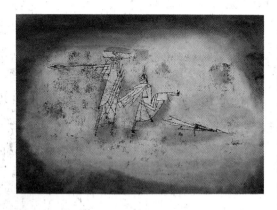

Fig. 17
**The Matter,
Spirit and Symbol
of Attack**

1922. Watercolour and oil
on paper, 33.5 x 47.5 cm.
Lady Hulton Collection,
London

Birds were a constant subject of Klee's attention and were made to bear a wide range of meanings, mostly benign but sometimes malevolent. Need we regard these grotesque little automata as birds at all? They have bird-like heads, but otherwise no connection with the avian kingdom. Yet Klee firmly called a closely related drawing *Concert on a Branch*. Perhaps he had been awakened once too often by the incessant chirping of birds at dawn! It has been suggested that the apparatus shown is a mechanical decoy for luring birds by imitating their sounds, but it is difficult to say if the venomous appearance of the creatures signifies Klee's disapproval of such a device. In any case they are apt symbols of treachery, malice and lies, all of which Klee no doubt encountered at this or other stages of his life. Superficially comic, the work is actually one of the most surrealist of all Klees; its sense of horror concealed behind a humorous facade is very much in tune with surrealist thinking.

As long as the crank is turned, the twittering machine is in perpetual motion. In his early Bauhaus years Klee was greatly concerned with how to represent motion, not just physical movement but the motion of the will. His line was excellently adapted to explore the problem, as in Fig. 17 where the arrow symbolizes a progression from the idea of violence through the will to be violent, and finally to the means of being so.

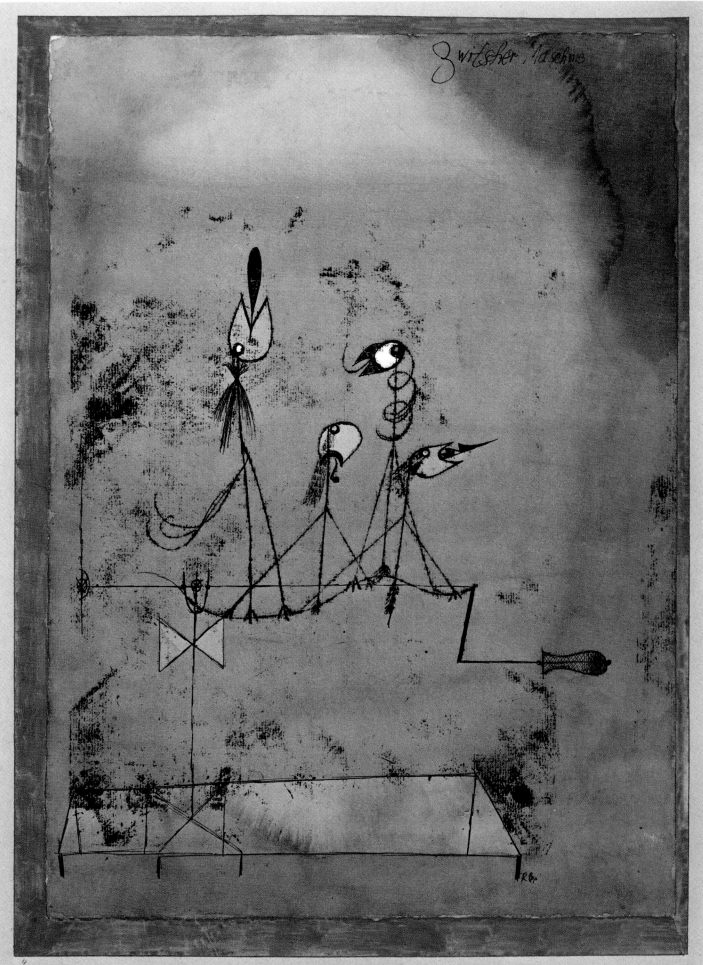

Zwitscher Maschine

1922/151 Die Zwitscher-Maschine

11 The Tightrope Walker

1923. Lithograph, 43.2 x 26.7 cm. Scottish National Gallery of Modern Art, Edinburgh

Plate 11 clearly belongs to the same group of works as the preceding, a group in which Klee uses his skill as a draughtsman to conjure up a world of absurd structures whose frailty mocks their carefully fabricated appearance. It seems to be an ironic comment on the replacement of human by mechanized organs. Just as in *Twittering Machine* the identity of the creatures hovers between birds and automata, the protagonist in Plate 11 is balanced between the human and the toy. The little stunt-man caught in the crossed spotlight beams symbolizes and presides over a structure which is intended to represent this balance of forces in a more diagrammatic way. The picture field is intersected by the rising light beam giving an off-centre axis for the whole structure, which is as delicately balanced round this axis as the stunt-man on his wire. The circus here evoked by Klee is magnified into full-blown drama in Fig. 18, where he has invented a comic opera in the style of Hoffmann as a peg to devise a paper battle between an intrepid, be-plumed explorer and three sad-eyed sea-creatures, justifiably resenting this intrusion on their island or ice-floe.

Fig. 18
Battle Scene from 'The Navigator'

1923. Watercolour and oil on paper.
Private Collection, Basel

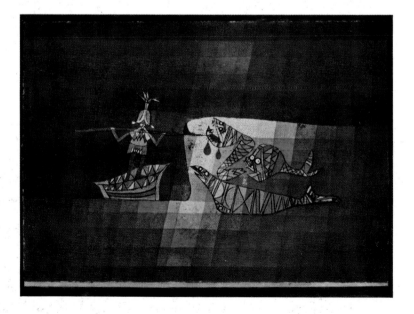

52

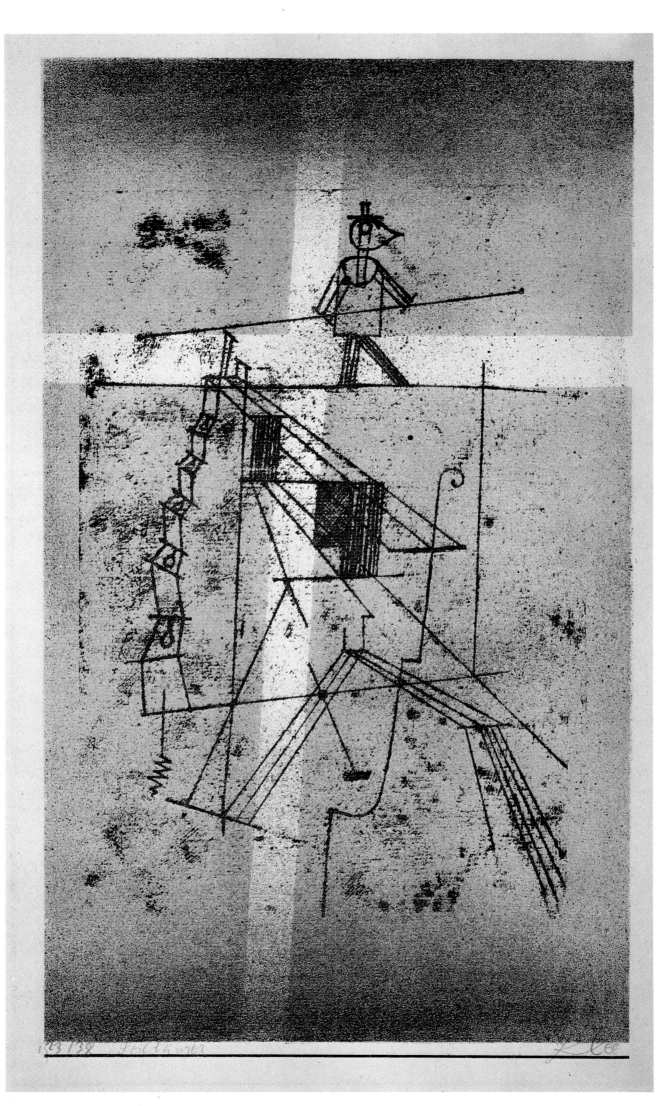

1921. Watercolour, 43.8 x 30.8 cm. Tate Gallery, London

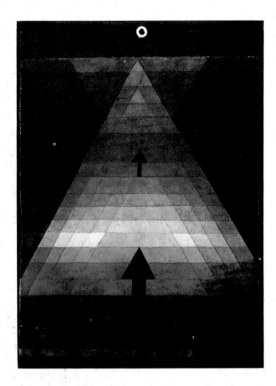

Fig. 19
Eros

1923. Watercolour,
33.3 x 24.5 cm. Rosengart
Collection, Lucerne

By contrast with Plates 10 and 11, where meaning is conveyed by unambiguous line, here line crosses and re-crosses to enclose shadowy planes of colour to most mysterious effect. Three or four strange creatures emerge from the shadows to surround the central figure, like devils in a Temptation of St Anthony. The maiden herself is strange with her multiple mouths and deformed ear, but she is elaborately dressed with cape and gloves, wasp waist and hobble skirt. She seems to sway on a round base like a ninepin, as if all too likely to 'fall'.

There are a number of more or less erotic works of this year, including the similar *Ceramic, Erotic, Religious*, which Klee helpfully subtitled *The Vessels of Aphrodite*. The ambiguity here results from the excess of imagery that flowed from this method of drawing, leaving Klee unable to distinguish a primary theme. On the other hand the wholly abstract *Eros* (Fig. 19) is strongly concentrated. It consists of an iridescent pyramid penetrating a smaller one descending from above, while two prominent arrows define the upward thrust. Making abstract equivalents for physiological or psychological states was a test Klee set his pupils at the Bauhaus, and *Eros* may therefore have had an exemplary purpose.

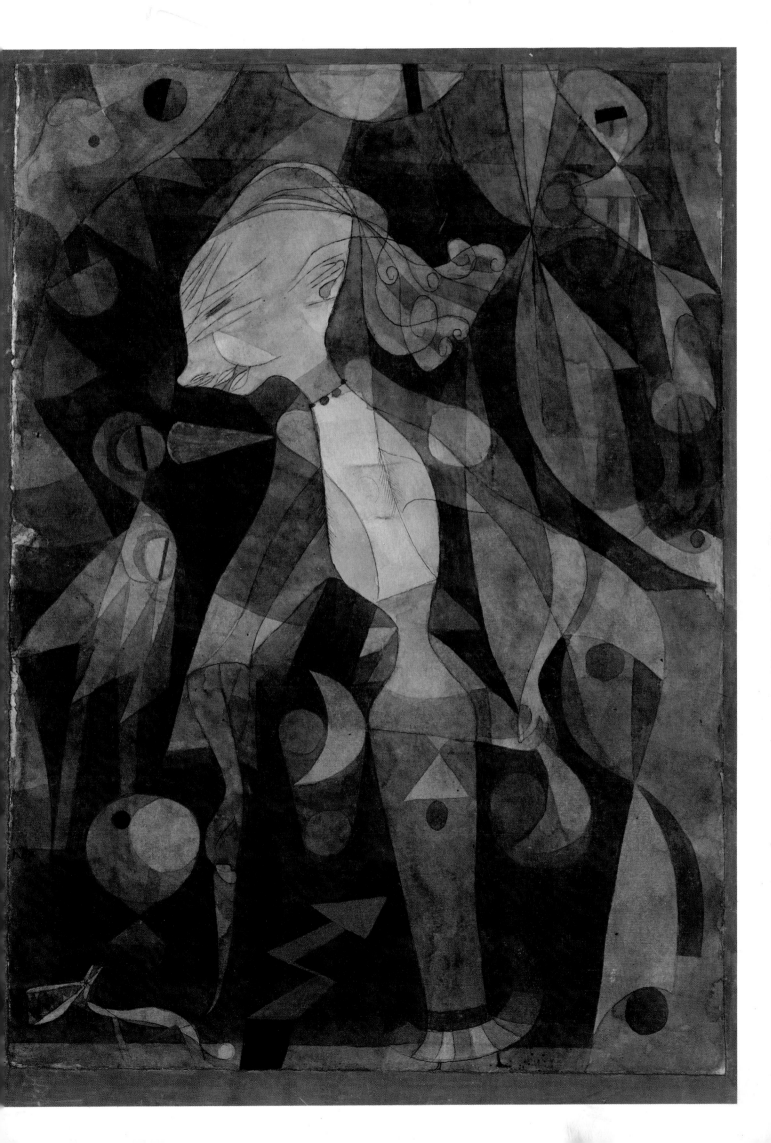

13 Puppet Theatre

1923. Watercolour on chalk ground, 51.4 x 37.2 cm. Paul Klee Foundation, Kunstmuseum, Bern

Even without its title, this delightful work would be recognizably from the same world of the imagination as Plate 7. Small booths on each side suggest the arrival of a Punch or a Judy. Whereas Plate 7 awaits the actors, here a charming marionette with stiff arms occupies centre stage. The line of the 'stage' is clearly shown and seems to correspond to a join in the paper. It is evident that the vertical black bar which bisects the colourful globe shape at the bottom has been superimposed over the original colours. Obviously the painting has been extensively modified during execution, and it appears in fact that the bottom strip was cut from another painting, *Still Life with Disc*, and pasted on. This would have been the occasion for Klee to unify the two parts with the overall black background that throws the colours into such prominent relief.

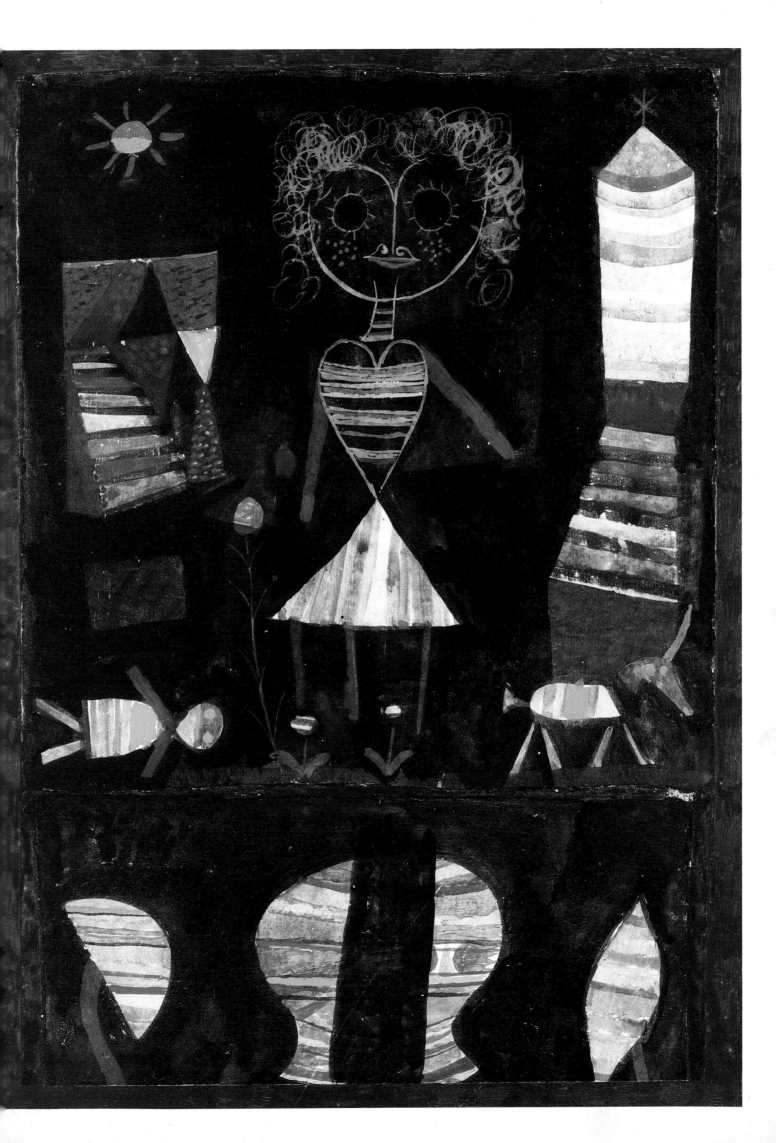

Crystal Gradation

1921. Watercolour, 24.5 x 31.5 cm. Kunstmuseum (Kupferstichkabinett), Basel

Klee's work moves constantly between the two poles of abstract structuring and narratives of the imagination. Not only does he colonize the whole of the territory in between but the poles themselves prove, as is often the case, to have much in common. To put it another way, Klee was always equally conscious of theory and practice. The place where these intersected was the Bauhaus lecture-room, and during his years there he was always conscious of the needs of his students. Klee taught a theoretical underpinning, which he considered to be like preparing the soil for the fruits of art to grow. One of his first lessons was how to manage the gradation of colours while preserving their purity. It was a process akin to his much loved music, and looking at Plate 14 reminds us of Klee's early remark quoted in the text, about the 'chromatic keyboard' of the paintbox. It is impossible to tell where on the page Klee started this supreme example of pictorial-musical composition, but each shape or 'theme' interrelates with the rest in a profoundly homogeneous way, and not without wonder and romantic feeling.

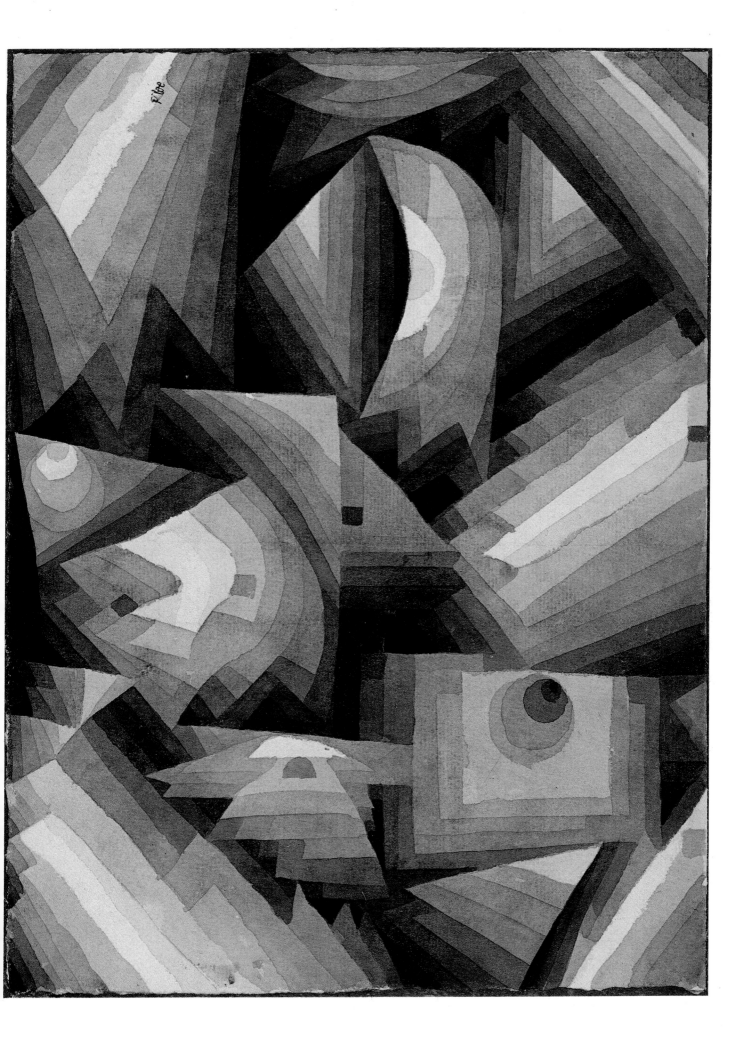

15 Fugue in Red

1921. Watercolour, 23.9 x 33 cm. Private Collection, Switzerland

The musical analogy inherent in all these paintings of graduated colours is here spelled out in the title. The comparison with a fugue in music is apt because here the superimposed forms retain their shape, as does the theme tune in a fugue. At the same time, the forms employed are less 'abstract' than the crystalline ones which prompted the name of Plate 14. Some of them, at least, have a more organic nature, and stray into another of Klee's intimate concerns, the business of portraying *growth* in art in parallel to nature. As growth is also inherent in the idea of a fugue, Klee here establishes the connection between music, nature and art in a way that must have been very satisfactory to him.

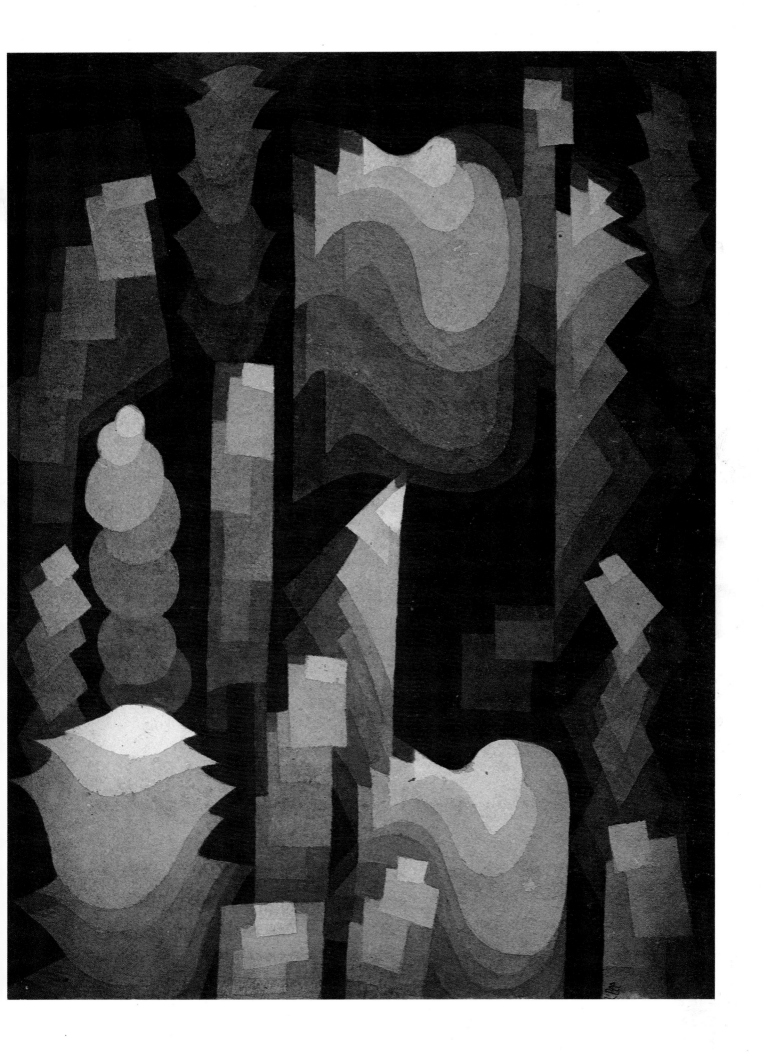

Reconstruction

1926. Oil on muslin, 36.3 x 39.3 cm. Kunstsammlung Nordrhein-Westfalen, Düsseldorf

We are so used to the careful structuring of Klee's works, particularly in the Bauhaus years, that it comes as a surprise to see one so apparently haphazard as this. In later years Klee would often compose with unconnected elements, at which time the empty intervals between them assumed very great importance. Here, the whole picture 'field' or 'ground' is the unifying factor, carefully worked and delicately tinted as it is. The objects placed on it are in fact well 'composed', presided over and held together by the misty sun. They all have an architectural character and, aided by the title, it is easy to read the painting as a building site, where the dust of construction mingles with the heat of the day to throw a yellowish pall over the view. The pictorial parallel is in the casual placing of these visual episodes, scattered about the surface as if waiting to be assembled into one of Klee's more customary dense architectural compositions.

The presiding sun was of perennial interest to Klee and is a feature of some of his most highly wrought compositions. It identifies their subjects in cosmic terms and makes us aware of time, season and atmosphere. If in *Reconstruction* it seems to denote oppressive heat, in *Arctic Thaw* it is the catalyst that sets the lines of the composition in motion to convey to Klee's imagination the thought of melting ice.

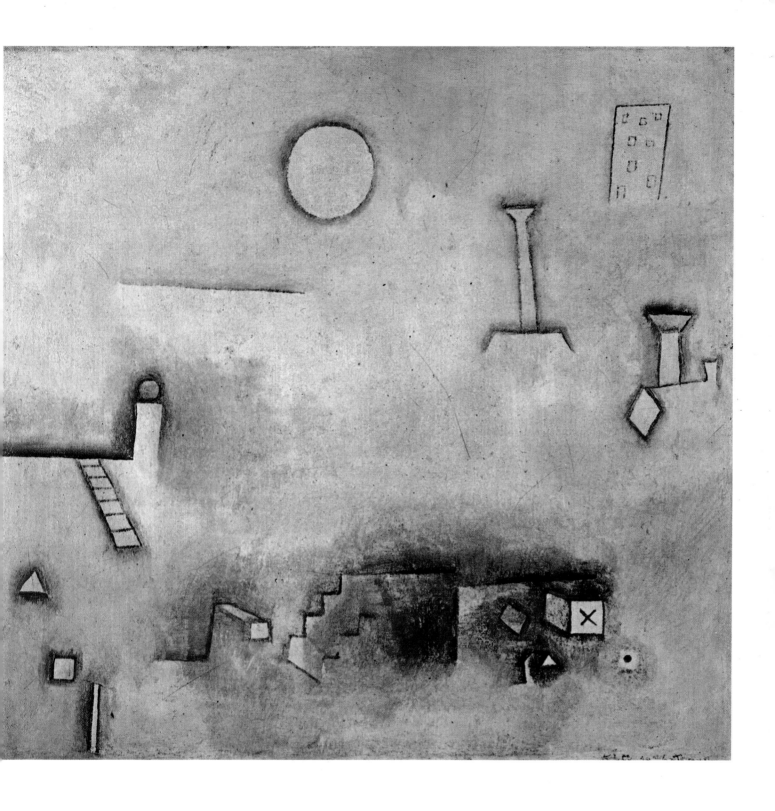

1924. Watercolour on paper on board, 23.5 x 31.1 cm. Paul Klee Foundation, Kunstmuseum, Bern

Fig. 20
Picasso:
Minotauromachia

1935. Etching and
drypoint, 49.8 x 69.3 cm.
Musée Picasso, Paris

Parallel to Klee's teachable precepts there existed in him a strain of imagination with roots in German myth, folk memory and fairy tale. He seldom gave it such full rein as in Plate 17. We see the mountains and a village, a woman in modern dress and a child wearing a mask. Nothing fearful is going on, but the effect is sinister, thanks mainly to the monstrous creature to right of centre. The form of this monster reminds us that although Klee's imagination was Gothic, the means he used were thoroughly modern, being derived in this case not only from his own practice but from Surrealism. The monster has a head and limbs – one leg ends in a high-heeled shoe – but there is a suggestion of struts and pulleys about it that is reminiscent of Duchamp or Picabia some ten years previously. Ten years later again, Picasso was to make a strange parallel to Plate 17 in one of the most famous of his prints, the *Minotauromachia* (Fig. 20), in which the Minotaur takes the place of the hybrid monster of Klee. Although the parallel is striking, the ambience and style could not be more different, replacing the Hoffmanesque fantasy of Klee with the classicism appropriate to a modernized Greek myth.

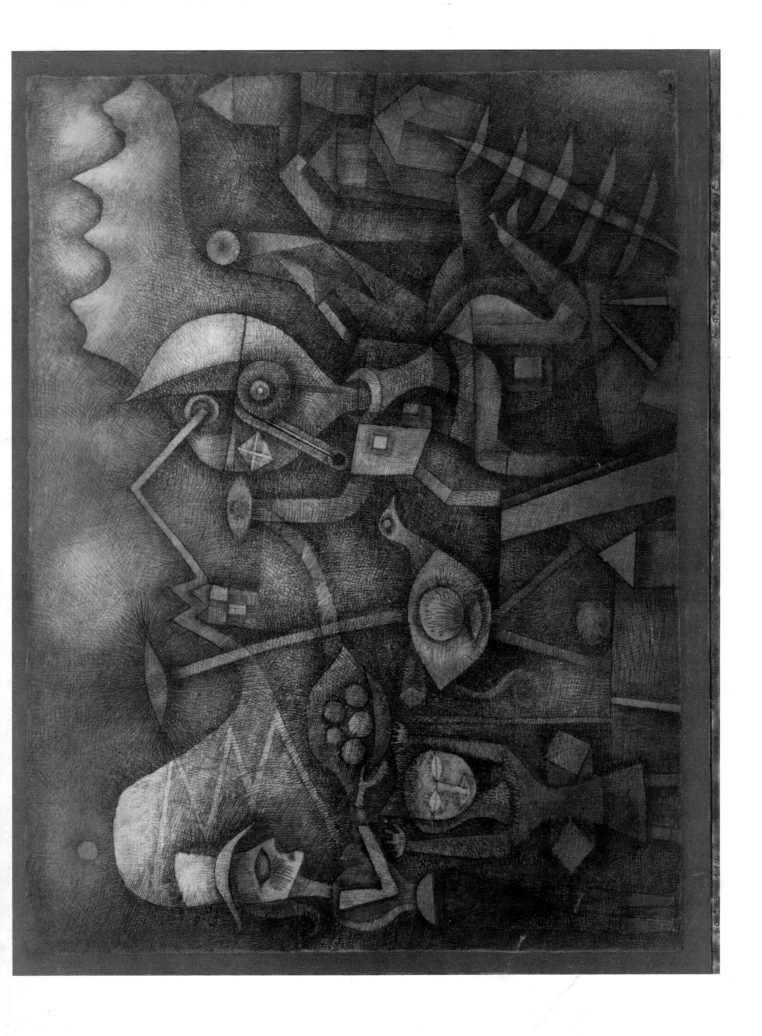

Botanical Theatre

1924/34. Oil and watercolour on board, 50.2 x 67.2 cm. Private Collection, Bern

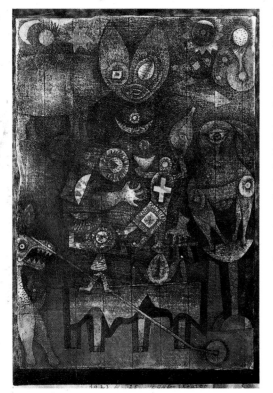

Fig. 21
Magic Theatre

1923. Pen and brush
and Indian ink, with
watercolour,
33.6 x 22.8 cm.
Paul Klee Foundation,
Kunstmuseum, Bern

This unusually elaborate work, which Klee worked on over a long period, unites two of his principal interests. There is an indication of folded curtain at each side, but the painting is theatrical in a general sense only, in that it presents a shallow box with a floor, backcloth and wings. The *mise-en-scène* is very elaborate and although Klee has named it botanical, few if any of the forms would be known to taxonomy. At the most it can be said that many of them belong to the cactus family and are primitive organisms with a powerful will to survive and flourish. At least one form has strayed from the animal kingdom – the little creature pacing solemnly to the right along the floor; and is that an owl just to the left of him? Moreover the large 'cactuses' on the right can be read as humans with uplifted arms. This ambiguity in the forms, united only in the mysterious life that grows under Klee's hand, creates that same disorienting, slightly sinister atmosphere noted in Plate 17. Here the ambiguity extends also to the composition, for some of the forms may be occupying the stage, but others appear to be painted on the backcloth. Or are they? The strange red form that hangs there is the 'heart' of the whole pictorial organism, and has a tangible substance. By such means Klee seems to take us into the recesses of nature, as if it were into the centre of some colony of insects obeying their own mysterious genetic rites.

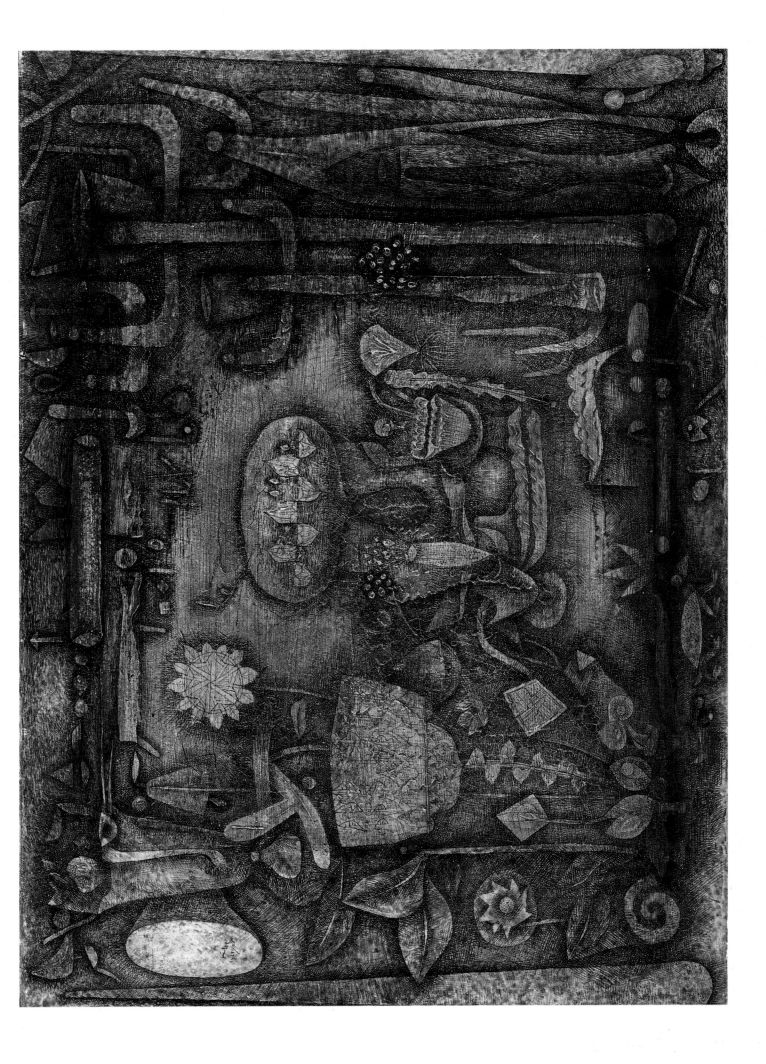

Pastorale

1927. Tempera on canvas on wood, 69.2 x 51.7 cm. Museum of Modern Art (Abby Aldrich Rockfeller Fund), New York

Parallels with music are easy to find in the work of Klee. Besides the analogies discussed under Plates 14 and 15, there is a more direct parallel here with the form of a musical score. Plate 19 belongs to a group of works in which parallel horizontal lines, as in a score, support a whole variety of marks and signs, suggestive of both letters and musical notes, but inflected to make them capable of various interpretations. One of them suggests orderly rows of plants with fences and stakes and was named by Klee *Horticulture*. Others are simpler (rows of grains of wheat) or more elaborate, mingling streets of houses with trees and other features of the urban scene. Plate 19 is one of the most regular and pattern-like of these works. With its strip of blue at the top it suggests a very schematic rendering of the landscape, containing among its many layers some signs of a botanical character and others that are architectural or structural.

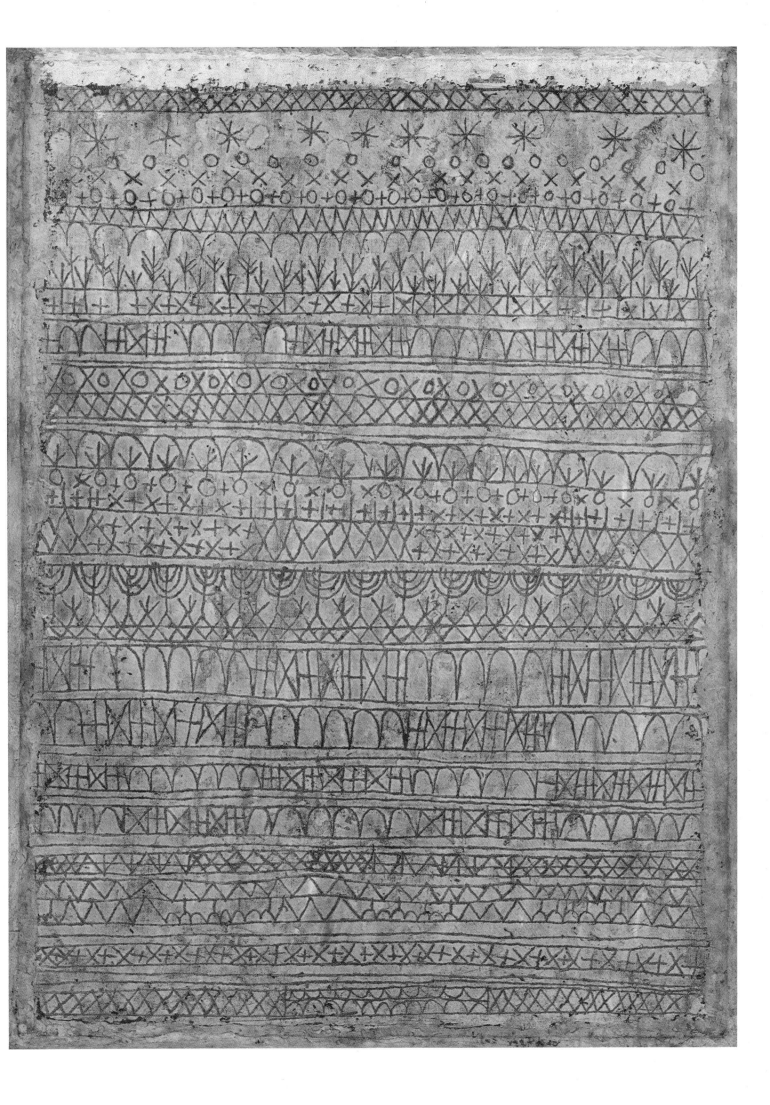

1926. Watercolour, 26.7 x 39.5 cm. Private Collection

Fig. 22
A Garden
for Orpheus

1926. Pen and Indian ink
on paper, mounted on
board, 47 x 32.5 cm.
Paul Klee Foundation,
Kunstmuseum, Bern

Klee's use of pure line was most highly developed in the mid 1920s and reached a high degree of complexity. Plate 19 showed one use of parallel lines; Plate 20, and even more Fig. 22, show the intricacies that can result when groups of parallel lines are used to represent interlocking planes and create illusions of perspective. Parallel lines can suggest many things, among them the trunks of trees in the forest, or the columns, the courses of brick or stone, the timbers and planks of buildings. Klee exploited the ambiguity between trees and columns in his *Forest Architecture* of 1925, and Plate 20 has a similar ambiguity. Which is the castle, which the forest? Do we see piles of timbers; is the rectangular motif in the centre an opening into a long perspective, or is it on the contrary the plan of the projected castle? On the evidence of other works, it is an entrance, leading deep into space, opening into a different world. Klee invested this motif with mysterious meaning; where it occurs in his garden or forest pictures it is the way out of paradise (see Plate 21). *A Garden for Orpheus* (Fig. 22) is the most complex and wonderful of all these drawings, and shows the romantic depth and feeling and the range of phenomena that can be represented in such a schematic way. Orpheus, the god of music, also descended to the underworld. Klee's drawing with its secretive doorway is a fit introduction to his adventure.

Gate in the Garden

1926. Oil on panel, 54.5 x 44 cm. Huggler Foundation, Kunstmuseum, Bern

In this oil panel Klee successfully transposes his parallel line technique from drawing to painting, enabling him to add the mysterious spatial effects of colour to those of line. The motif of the entrance, referred to under Plate 20, suddenly assumes greater importance. It is no longer integrated with a whole petrified structure of lines, as in the drawings, but hangs in space like a portent, while its red colour conveys a warning to the heedless who might stray through it. This is one of the earliest premonitions of Klee's awareness of mortality that is such a moving feature of his late works. Gardens had a special significance for Klee, aware as he was of the garden not only as the scene of mankind's creation and fall, but as the place of civilization fenced in against barbarism. To leave it was to encounter danger and fear of the unknown, yet every dweller in the garden had ultimately to pass through the gate.

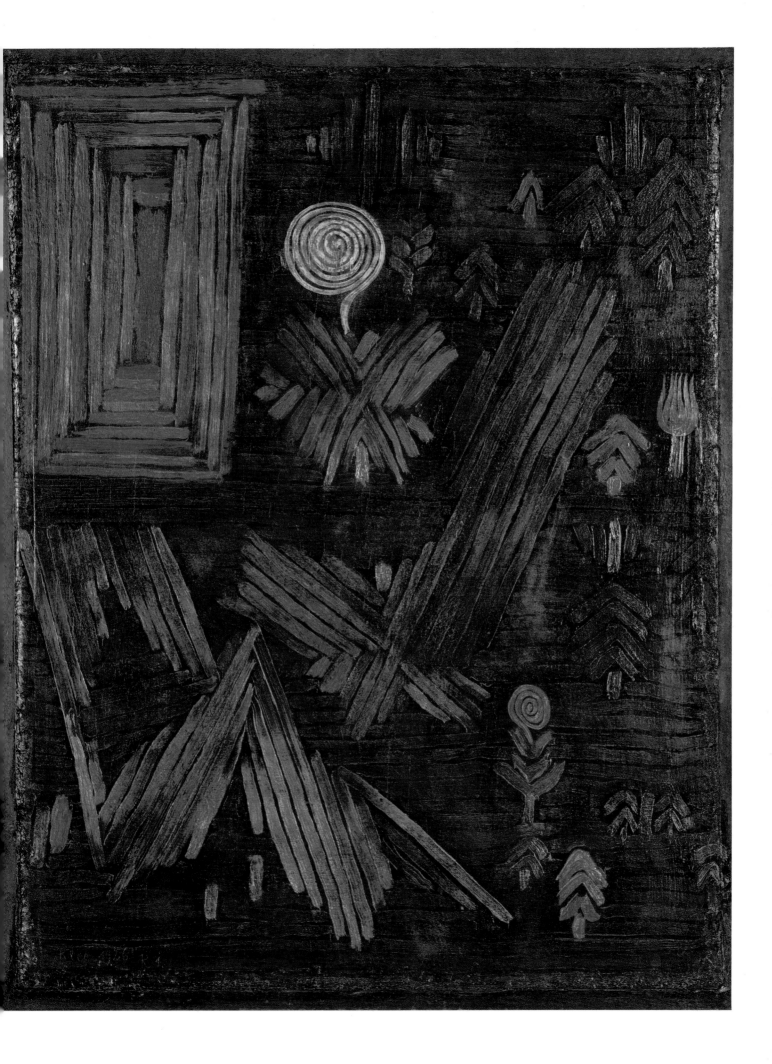

Fish Magic

1925. Oil and watercolour varnished, 76.8 x 98.1 cm. Museum of Art (Louise and Walter Arensberg Collection), Philadelphia

Fish Magic is a further example of the works already noted as inspired by the theatre, or more probably the puppet theatre. Like Plate 7 it is elaborately worked on, and is one of Klee's largest paintings up to its time. Curiously, Klee has pasted a separate piece of canvas to the left centre. The resemblance between a fish tank and a stage did not escape Klee, who has fostered it by a hint of curtain at the top left corner, and by the odd little figures who look out from inside the proscenium opening. But this is no ordinary aquarium, nor stage, inhabited as it is by fish, plants and celestial bodies all together. Their timeless world is observed by two 'representatives' of the human race, and is invaded by time in the shape of two hourglasses and a steeple clock lowered into the scene in a net or fish trap. In a detailed analysis of this work, Richard Verdi suggests that the additional piece of canvas represents a zone of time, through which fish pass indifferently but which alters the character of the principal human figure, whose head it divides into halves. This little person with two faces looks solemn on the left within the human time-scale, joyous on the right within the time-scale of the natural world. Klee's work shows many such analogues of divided humanity, contrasted with the unitary laws of nature.

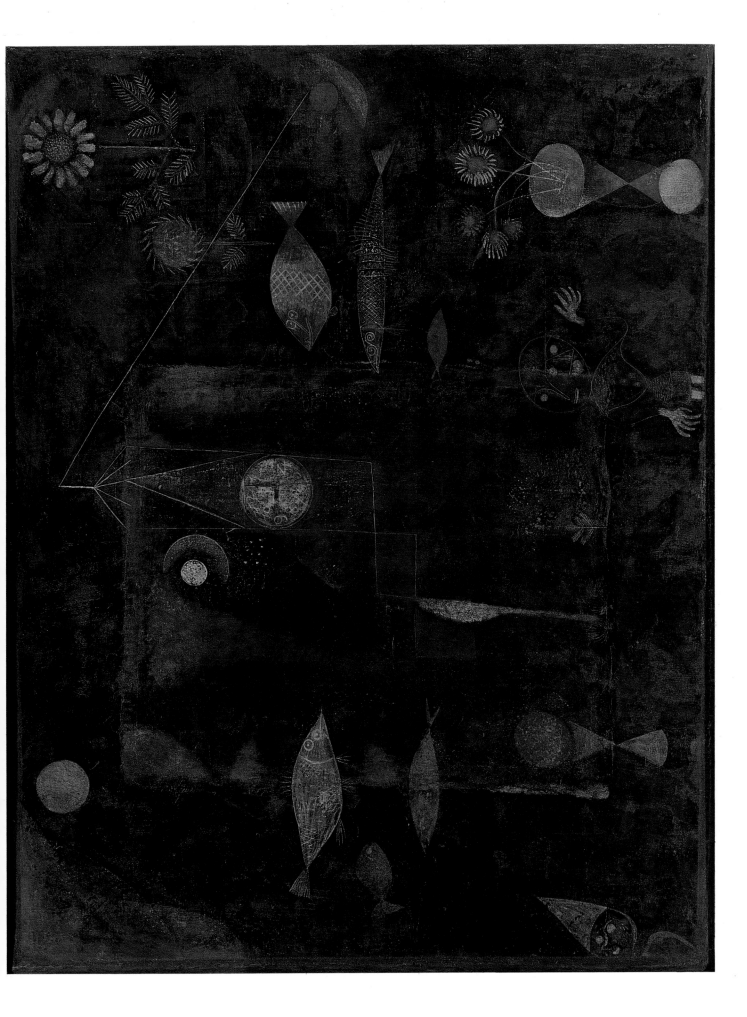

Around the Fish

1926. Tempera and oil, 46.3 x 64.1 cm. Museum of Modern Art (Abby Aldrich Rockefeller Fund), New York

Compared with Plate 22, Klee's other great fish picture is rather stark and diagrammatic, but the central motif of the carp in a blue dish is memorably painted. Although dead (very dead) rather than cooked, this does seem to denote fish offered as food, which prompts Verdi to suggest that the picture represents a cycle of nature, a sort of food chain. Both the title and the circular arrangement of the symbols, *around* the fish, might support this idea. But it remains a puzzle why, alongside the rather realistic fish, Klee adopted these diagrammatic symbols of basic life, for they are hardly more. Such diagrams can only denote the most primitive organisms, and these have more in common with dynamos than with protozoa. The most puzzling feature of the work is the tiny schematic human head, growing on a stem in a vase like a cut flower, and itself partly formed from one of these primitive life symbols. This head receives an emphatic message from the fish, indicated by an arrow and an exclamation mark. If man is normally at the top of the food chain, he is not in a privileged position here, for nothing could be less symbolic of gastronomic pleasure than this agonizing assault by the fish on the human senses. Perhaps Verdi is right, and Klee meant to puncture mankind's pretensions to have the best of everything, and remind us that we come from primitive life and will return to it.

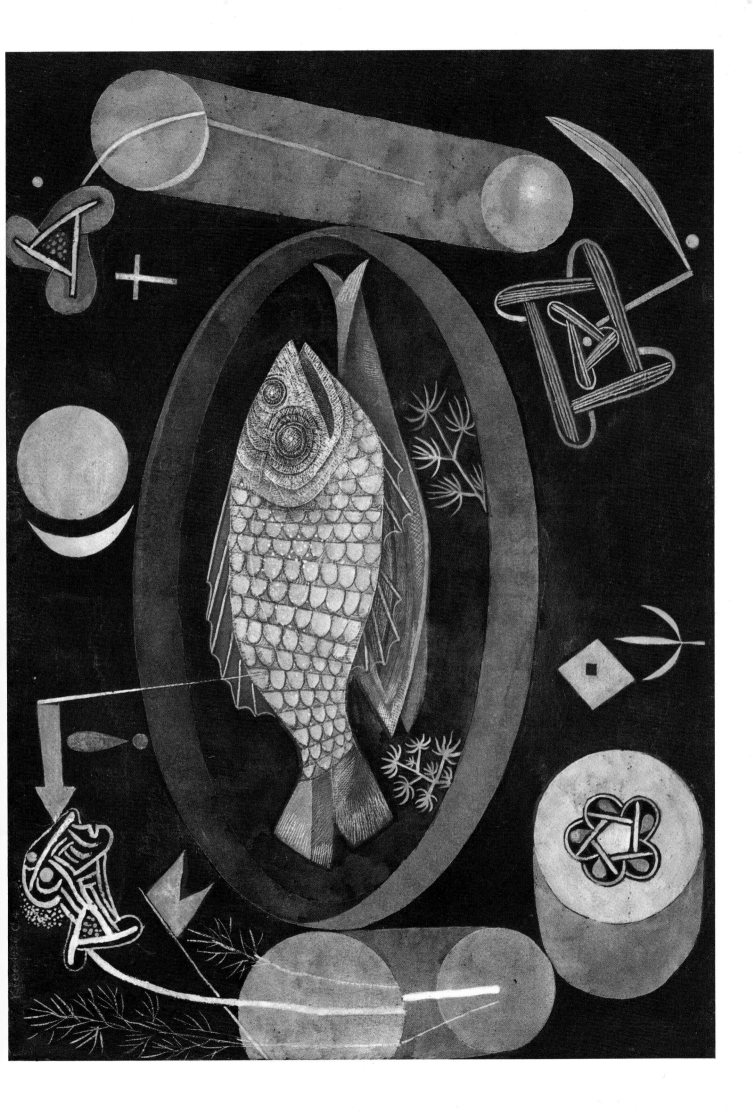

Threatening Snowstorm

1927. Pen and ink and watercolour sprayed, 48.9 x 31.4 cm. Scottish National Gallery of Modern Art, Edinburgh

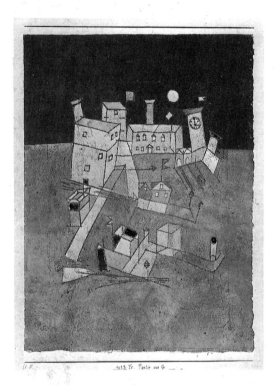

Fig. 23
View of G
(Partie aus G)

1927. Watercolour and oil
transfer on paper,
mounted on board. Sold
Christie's, New York,
14 November 1984

Klee's invention in the use of line is limitless, yet line has its own disciplines so that similar configurations keep reappearing. Line can be impersonal and mathematical, or it can be personal, intuitive and compulsive, and Klee's work is rich in examples of both kinds and the variety in between. In Plate 24 all the lines are straight, and approximately vertical or horizontal, diverging just enough to give the resulting structure a pleasing irregularity like a street of ancient buildings. In fact Klee's title invites us to read it as a town, and typically Klee inserts a small visual clue to help make the connection – the pitched roof of the tallest building, on the left. Klee uses this convention to convey towns or habitations on many other occasions. *View of G*, a town in Corsica (Fig. 23), takes representation a stage further, but the skeletal drawing underlying it is not dissimilar. It has a clarity appropriate to the Mediterranean, but it may be thought that Plate 24, with its doom-laden surrounding atmosphere, more than makes up for any loss of this clarity in suggestive power.

Klee

1927 Omega 1 drohender Schneesturm

Little Jester in a Trance

1929. Oil and watercolour on hessian, 50 x 35.5 cm. Museum Ludwig, Cologne

A large group of Klee's drawings are of a type he described by the musical term polyphony, and are sometimes entitled as such (see Plate 31). They depend for their beauty on the intersecting of curved lines which enclose one or more figures, like the intersecting instrumental lines in music. This was Klee's rationalization of the idea of 'automatic' drawing put about by the Surrealists, who advocated drawing by following the momentary impulses of hand or brain, with as little conscious thought as possible. Klee's essays in this direction had no predetermined subject, and the flow of the lines suggests rapidity of execution, but they invariably show his innate accuracy and sense of placing. Plate 25 began with a monotype of two years earlier, drawn with a single line. In the latest version, shown here, Klee tidied up the intersections of the line, and added an eyeball and the coloured hatching within the areas bounded by the criss-crossing lines. These adaptations created a memorable image, with a pseudo-Cubist modelling and shallow penetration of the surface. But by tracing with a pencil, starting on the loop on the left leg, and finishing at the wrist of the left hand, one may prove to oneself that the drawing could indeed have been executed without lifting the pen from the paper.

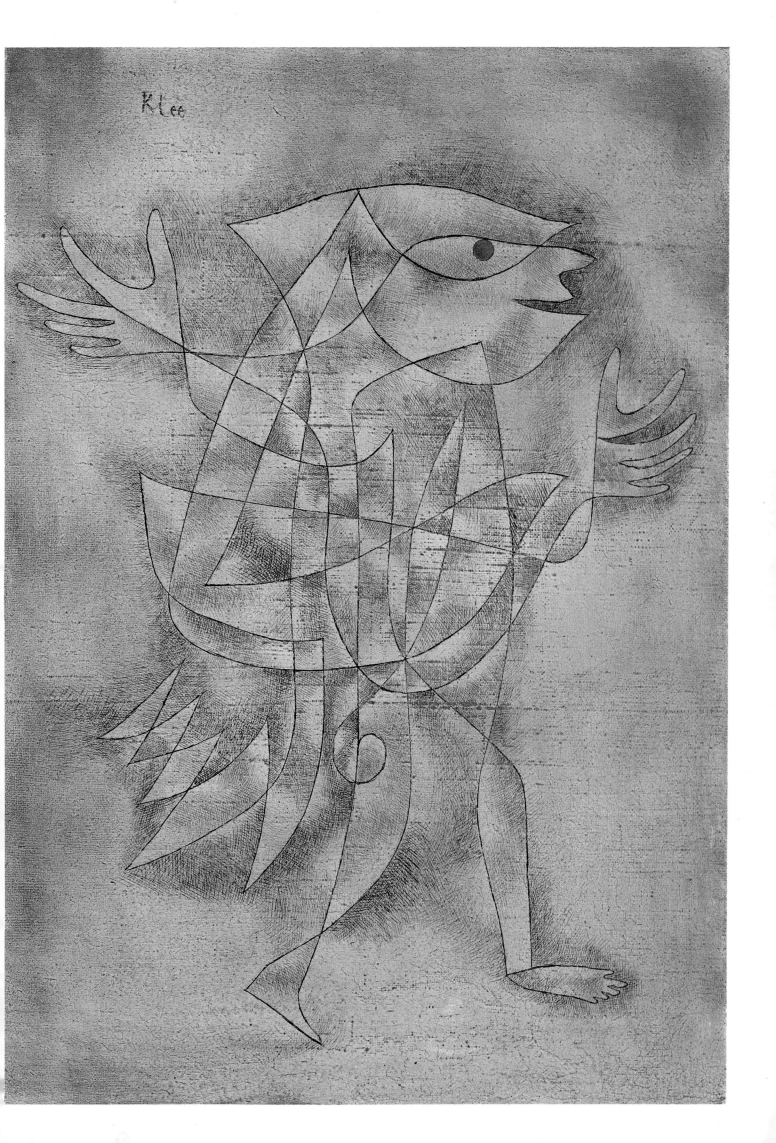

1929. Watercolour, 46 x 30.5 cm. Paul Klee Foundation, Kunstmuseum, Bern

Fig. 24
**Highway
and Byways**

1929. Museum Ludwig,
Cologne

Klee's visit to Egypt in the winter of 1928/9 confirmed him in the belief
that a true synthesis between the mathematical construction of pictures
and the world of appearances was possible. In Upper Egypt he found a
landscape already laid out in the most structured way. Klee's fascination
with structures of parallel lines has already been noted. Because the flat
Egyptian landscape is laid out in strips, the visit encouraged him to think
in terms of horizontal lines defining strata – i.e. layers. This horizontal
format gave a clear framework for the mathematical permutations visible in
these works. It will be observed that in Plate 26 at every point where a ver-
tical line crosses a horizontal one, the layers on each side of the vertical are
halved or doubled. In that way the thickest layer is sub-divided into halves,
quarters and eighths. As a rule the colour is more intense the thinner the
layer.

But how much did all this matter to Klee? In his view a picture conceived
in this way might 'find its way back to reality', and the Egyptian pictures
suggest that he strove for this result. As described in the text, Plate 26 is a
perfect analogue of the landscape there. It has a companion, *Monument on
the Edge of Fertile Country*, which even mirrors the progression from the cul-
tivated land bordering the Nile through the zone of monuments to the
desert escarpment. How romanticism keeps breaking into Klee's geometry
is illustrated by a masterpiece of this series, *Highway and Byways* (Fig. 24),
where we see, as if from a great height, the traces of a great avenue reced-
ing into the distance, accompanied by the meandering pathways of lesser
men.

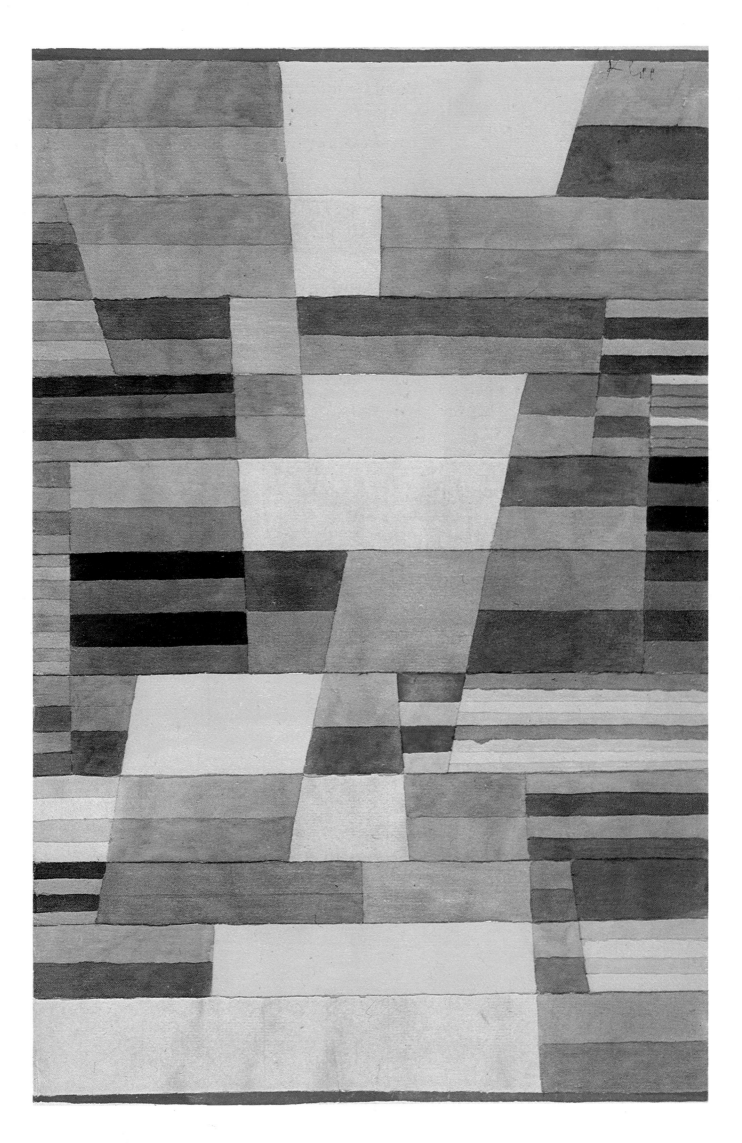

Fire in the Evening

1929. Oil on board, 37 x 36 cm. Museum of Modern Art (Mr and Mrs Joachim Jean Aberbach Fund), New York

Fig. 25
**In the Current,
Six Thresholds**

1929. Solomon R.
Guggenheim Museum,
New York

This may not easily be recognized as one of the Egyptian paintings, since it deals not with the crystal daylight of Upper Egypt but with its equally beautiful, short-lived twilight. It is laid out on similar principles to Plate 26, with each vertical line sub-dividing the layers it passes through, but the rule regarding density of colour does not apply, Klee perhaps thinking that this rule was subverted by the withdrawal of daylight. As night falls, the squat rectangle of red to right of centre assumes maximum importance, and draws the eye like the glow of a fire in the evening, just the title that Klee adopted. He was not however carried away entirely by these associative values. By his titles Klee sometimes insists on focusing attention on the mathematical construction, for example *Individualized Measurement of Strata* (Paul Klee Foundation, Bern). *In the Current, Six Thresholds* (Fig. 25) is ambiguous in this respect. The thresholds of the title are the six vertical lines which, reading from the left, cause the horizontal layers to join (or reading from the right, to divide) by twos. Thus it is an abstract painting based on arithmetic but, by introducing the word 'current', Klee still invites the visual imagination to see the painting in terms of nature, this time a river, meeting six obstructions which modify the pattern of its flow.

Ad Marginem

1930. Watercolour varnished, 46.3 x 35.9 cm. Kunstmuseum, Basel

More than a year after the visit to Egypt, visual memories of it can still be detected here. This is one of the last examples of Klee's detailed technique of drawing that defines the form, as he put it, exotopically, that is by shading outside the form not within it. His approach to his work was beginning to change, moving away from the urgent complexity of method and meaning to pursue more purely pictorial ends. Something of the new mood can perhaps be seen in the empty centre here, a space cleared for the immense red globe that occupies it. The most interesting comparison is with the earlier 'stage' pictures such as Plate 18. At first glance Plate 28 might seem to be of the same kind, until we see that the objects on the margin are oriented towards all four sides, suggesting that the picture plane is not vertical but horizontal. We are perhaps looking down into a pool in which objects are reflected, or perhaps upwards through the greenish waters of the Nile which mercifully filter the relentless heat of the sun.

Fruits on Red

1930. Watercolour on silk, 61.2 x 46.2 cm. Stadtische Galerie im Lenbachhaus, Munich

This delightful and playful work has a sub-title, *The Musician's Handkerchief*, and started life as the red silk cloth that Klee placed under his chin when playing the violin. Klee was always interested in the material substance of what he was using, an interest that perhaps derived from his wartime use of fragments of aeroplane fabric. It was natural, then, that he used the handkerchief in its entirety, taking its wavy edges as the starting point for the filigree of delicate branches bearing the 'fruits' of the title. Some of these are themselves made of circles of similar fabric delicately pasted on. As in Plate 28, the composition is sparing and makes much use of empty space, which renders it specially attractive to the taste of our own period with its interest in the minimal statement, and its acceptance of the Zen-inspired belief that 'less is more'.

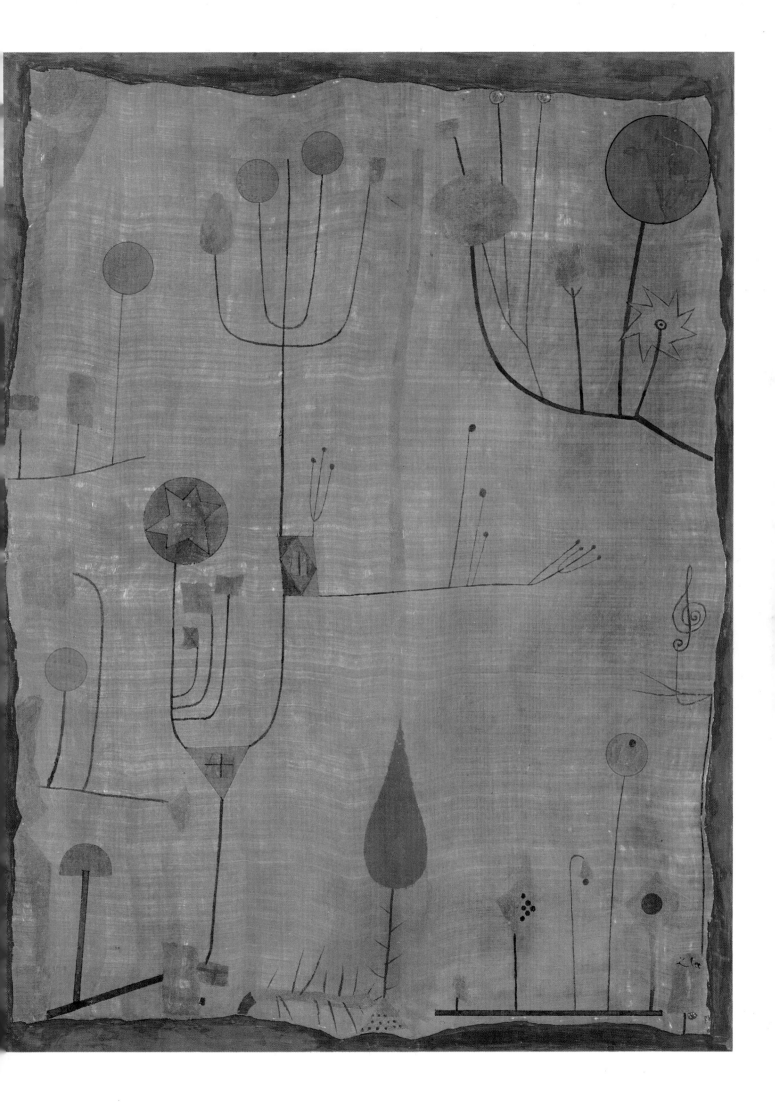

1930. Watercolour, 41.6 x 34.2 cm. Paul Klee Foundation, Kunstmuseum, Bern

Fig. 26
Daringly Poised

1930. Watercolour and
Indian ink on paper,
mounted on board,
31 x 24.6 cm.
Paul Klee Foundation,
Kunstmuseum, Bern

In this work Klee returns to a mathematical basis as in his Bauhaus exercises, but does not resist giving it a humorous interpretation. The composition derives from a watercolour such as *Daringly Poised* (Fig. 26) which is an essay in how to convey equilibrium in terms of shape and density of colour. That watercolour in turn reflects the concerns of a large number of geometrical drawings which Klee produced in 1930/31 during his last year at the Bauhaus. They represent an almost unknown Klee – the methodical constructivist – but as Christian Geelhaar points out, they are also the swan-song of his Bauhaus interests and mark the end of his preoccupation with theory. Plate 30 is contemporaneous with these drawings and seems to suggest a certain irony toward their production. What began as a diagrammatic reflection on mass, weight and energy has become an image of fatuous bravado. The constructivist drawings had a more serious issue in the large paintings that are an unusual aspect of Klee in the early 1930s (see Plates 33 and 34).

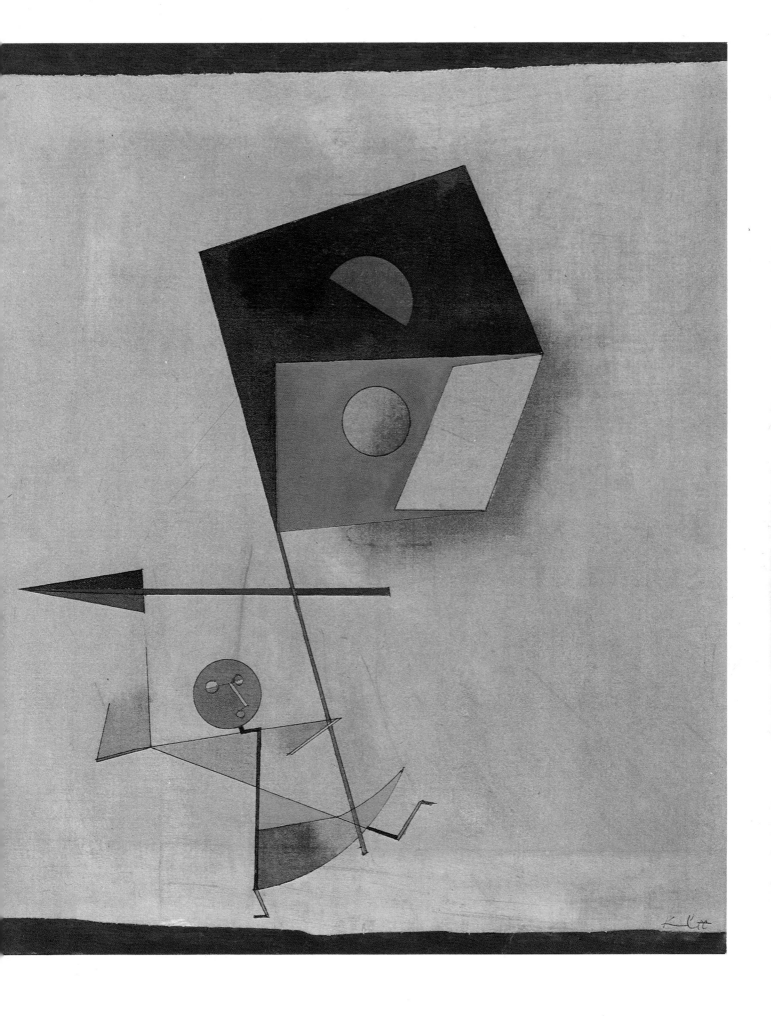

1931. Watercolour and pencil, 48 x 63 cm. Formerly Fischer Fine Art Ltd., London

Fig. 27
Dynamic -
Polyphonic Group

1931. 31.5 x 48 cm. Private
Collection, Switzerland

As noted under Plate 25, Klee took up an idea of the Surrealists' regarding spontaneous drawing and gave it his own specially musical interpretation. Plate 25 is a precursor of the true 'polyphonic' drawings, since it is done with a single line constantly crossing with itself but ultimately describing a single form. In the true polyphonic drawings there must be more than one form, corresponding to separate themes in music which must be harmonized. Just as in music some effort is necessary to distinguish the parts aurally, more than a glance is needed to separate the forms in Klee's drawings. In this example a large complex motif (or subject as the title has it) enfolds two smaller ones. Klee has given substance to these motifs by shadowing them in colour, purplish brown for the large, pink for the two smaller. It will be observed that this shadowing is always consistently on one side of the line, thus appearing 'endotopic' in some places and 'exotopic' in others. Fig. 27 is a still more intricate example, showing what spatial effects and almost material sculptural presence could be obtained by these means.

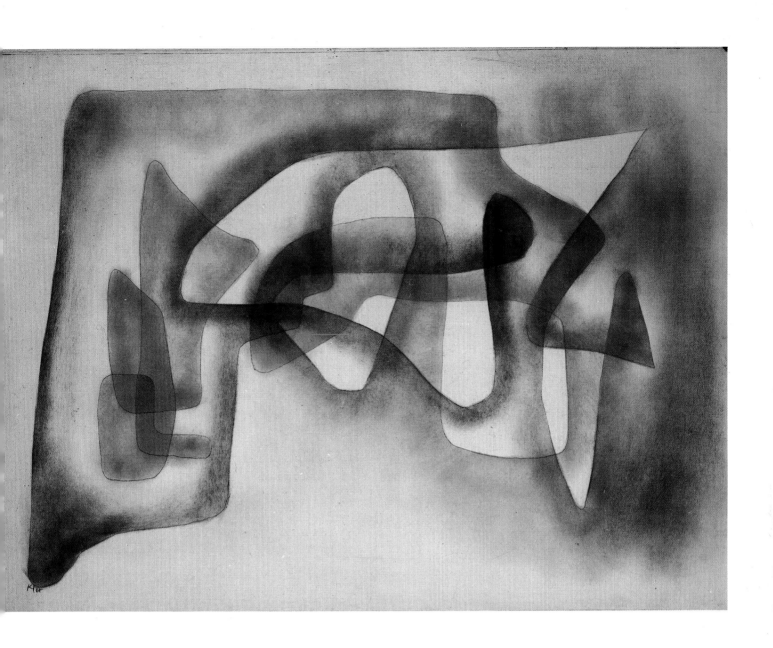

Uplift and Direction (Glider Flight)

1932. Oil on canvas, 90 x 91 cm. Sold Christie's, London, April 1989

Klee's work had always included many allusions to flight and weightlessness. In his last year in Germany, and in the wake of the constructivist drawings referred to under Plate 30, he made a firm intellectual effort to construct a quasi-logical (but in fact non-rational) system to convey the sensations of overcoming gravity and reaching into what he called 'the silent, pure and natural dynamism of the cosmos'. Geelhaar lucidly explains how Klee established a system of *non-rational connections* to subvert the rational system for depicting three-dimensional structures on paper, as used by architectural and engineering draughtsmen for generations. This locked the structure into a stable and static state, whereas Klee's intention was to do quite otherwise. His device was in essence simple – to link the corners of his plane surfaces, such as parallelograms, with *more than one* different plane, thus implying that the operation of the fourth dimension (time/movement) had changed the relativity of the planes while retaining their character as structures in space. Plate 32 is the most highly wrought work to come out of these exercises and successfully conveys a sensation of soaring and floating. According to his established practice Klee also added graphic symbols to convey the forces of thrust and gravity, and to locate the action in the open skies.

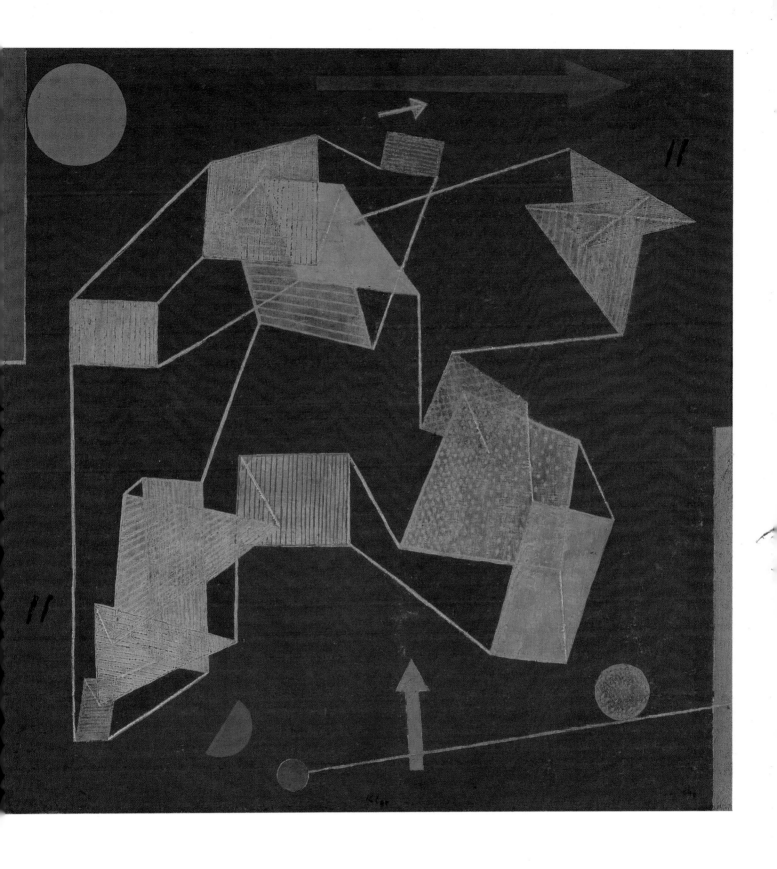

Polyphony

1932. Tempera on linen, 66.5 x 106 cm. Emanuel Hoffman Foundation, Kunstmuseum, Basel

In 1932 Klee used visual researches like those noted under Plates 30-32, and many others, to help him construct certain paintings of larger size, using a 'pointillist' technique of dots or little squares which he had first tried in 1930. It may be puzzling to find again the musical term polyphony in a context so different from that of Plate 31. The most basic difference here is that the polyphonic principle is now expressed in overlapping planes of colour, not in forms defined by lines. To make the difference clearer this group of works employs straight-edged planes such as rectangles or triangles. In *Polyphony* the overlapping planes are hardly distinguishable by their boundaries, because neither the colours nor the areas of dots correspond with them. We therefore have a multivalent system of harmonies which is sustained over the whole surface of a large (for Klee, that is) canvas. The analogies it promotes are those for which Klee always strove, between nature, art and music. On the one hand there is the shimmering veil of coloured atmosphere, through which impressionism and pointillism taught us to view the visual scene with its many ambiguities. On the other hand there is the visual music which combines the polyphony of Mozart (Klee's most venerated composer) with the tonal colour of Debussy.

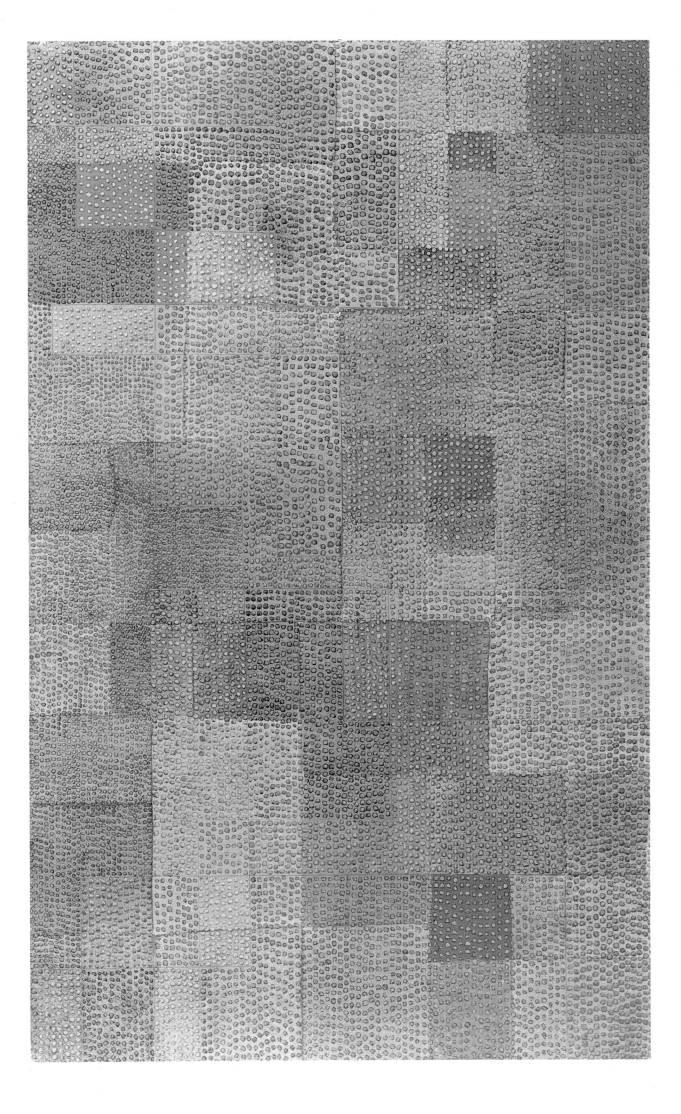

Ad Parnassum

1932. Oil on panel, 100 x 126 cm. Paul Klee Foundation, Kunstmuseum, Bern

Plate 34 shows Klee's grandest picture, grand in its relative scale, its highly wrought surface, and the sense of aspiration to which both the title and the pictorial subject bear witness. Klee had used the motif of a conical mountain as far back as 1915 in his watercolour *The Niesen* (Fig. 28), but in view of his recent visit to Egypt we may suppose that in Plate 34 he had a pyramid in mind. He gave the title *Pyramid* to another large painting of the same year. Although *Ad Parnassum* belongs to the same group as Plate 33, the strictly polyphonic structure is relaxed in favour of a more emphatic pictorial composition which employs regular well-balanced geometric forms, but subordinates them to the creation of a mysterious and imposing atmosphere with an acute sense of place. Andrew Kagan has shown that, although less strictly polyphonic *Ad Parnassum* is capable of detailed musical analysis. At the same time it is a work to which the term theatrical could be properly applied, for without any of the props of his earlier stage pictures it seems to set out a location for dramatic action. The little rectangles out of which the painting is built recall not so much the brush-strokes of the pointillists but the *tesserae* of mosaics or, even more, the regular horizontal courses of brickwork or masonry. Their colour varies from an intense blue to a bright brick red, and the colour relationship with their background constantly changes, causing the surface to hover between the materially present and the immaterially distant.

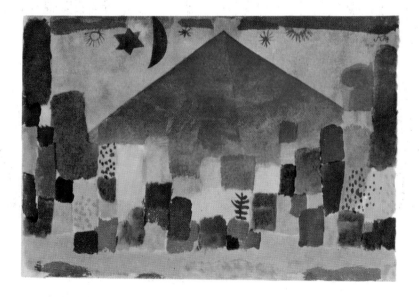

Fig. 28
The Niesen

1915. Watercolour.
Private Collection, Bern

The Future Man

1933. Watercolour applied by spatula, 61.8 x 46 cm. Paul Klee Foundation, Kunstmuseum, Bern

From the year 1933 Klee was obliged to mark time. He was dismissed from his post at the Düsseldorf Academy but, hoping for some turn for the better, did not leave Germany for Switzerland until the end of the year. It was time for a retreat into himself. In this work Klee has taken up one of his 'polyphonic' drawings of two years before, consisting of two 'subjects', completed the head and added arms and legs to produce an image of an infant in skirts. He has filled in its profile, not distinguishing the original polyphonic subjects, and the background with a technique peculiar to this period, of gouache or watercolour applied in paste form with a spatula, creating an impression of relief.

1933 Y 5 der Künftige

Blossoming

1934. Oil on board, 81.9 x 81.3 cm. Kunstmuseum, Winterthur

The year after his return to Switzerland was not a productive one for Klee, and it was then that the first signs of his fatal illness appeared. Naturally he continued to do original work but he relied to an extent on a number of well-tried themes. Plate 36 is a variation on his grid and stratified works, but with less arithmetical rigour in its design, while the grid on which it is based is wavy like a net moving in the wind. The title *Blossoming* again seeks to force the spectator to make that connection between an apparently abstract painting and nature, that Klee thought so vital. Klee had already tried to make an analogy between geometric abstraction and flowers, e.g. in two pictures of 1927, *Harmony of the Northern Flora* and *Resonances of the Southern Flora*, in which he points up the north/south polarity on the basis of the colour of the squares and the rigidity or otherwise of their boundaries. *Blossoming* uses some of the same devices as the 'Egyptian' paintings, with bright colours confined to the smallest rectangles and concentrated into the centre. Earthy colours predominate round the edges, inviting us to read the composition as a flowering plant growing in a well-weeded soil.

Drawn One

1935. Gauze, 30.5 x 27.5 cm. Kunstsammlung Nordrhein-Westfalen, Düsseldorf

Klee's title, a noun derived from the past participles of the verb to draw, is difficult to render in English. In Klee's usage it implies something derived from being drawn, not merely something that has been drawn. That makes the painting a meditation on the power of drawing and painting to create life or personality. Had this been a realistic depiction of an imaginary person, the point would have been banal and unnecessary. In fact this earnest round-faced personage emerges at the last moment, so to speak, from an abstract composition of circle and angles, with the simple addition of eyes and mouth. Klee was to use this method of personification increasingly often, e.g. in *Angel in the Making* of the same year, and it makes the portrait-element in *Senecio* (Plate 9) look very deliberate. Even in the extremely emotive and emotional *Struck from the List* of 1933 (Fig. 6), reasonably taken to be a reflection of Klee's dismissal from his teaching post, the transformation of an abstract painting to a symbol of dejection and disappointment is carried out by very few touches indeed. This ability to convey an emotional charge by the tiniest modifications is a remarkable characteristic of Klee's late work.

Walpurgis Night

1935. Gouache on fabric, 50.8 x 47 cm. Tate Gallery, London

Although it does not yet show the principal characteristics of Klee's last period, Plate 38 seems to be moving into a more shadowed world. Klee had dealt with some fearsome aspects of German myth before, but never with such a willingness to create the maximum *frisson*. There is no formal underpinning here, which makes it an unusual work. That is not to say the image does not arise directly, almost as a by-product, from the technical means employed. It is in gouache applied with a flattened object, as in Plate 35, but this time in long strands like coarse hair, a fitting analogy for conjuring up these terrifying witches. Klee has let his hand have free rein in twining these strands, with results that take him again into the camp of the Surrealists, since the appearance of this work suggests that both the form and content were evolved spontaneously during execution. Klee had already dipped into the world of Germanic folk tales on a number of occasions since returning to Bern, for example in *Rubezahl's Son*, 1934, which however is a realistic and premeditated image, not a spontaneously suggested one.

Jewels

1937. Pastel on cotton, mounted on canvas, 57 x 76 cm. Kunstsammlung Nordrhein-Westfalen, Düsseldorf

In 1937 Klee had been suffering for three years from a progressive disease, sclerodermia; he had three more years to live. An account of the 'late style' should certainly include the deterioration of his physical strength, which would make the obsessive detail and the elaborate preparation of his surfaces, less and less practicable. That is no doubt the basic reason why his late works are painted with a simpler brush technique and larger forms. It is impossible to judge whether Klee would have taken the same direction if he had kept his health; the important thing is that the late style was a logical development from the earlier, and Klee found it a suitable medium to express his innermost feeling. Plate 39 follows from the polyphonic paintings of overlapping planes like Plate 33. It is when we consider the role of line that a change is apparent here. We have been looking at examples of continuous intersecting lines, profiling complex shapes. Suddenly we now find lines that are broken, fragmentary, on the way to becoming not so much lines as shapes in themselves. These short, staccato lines occasionally mark a boundary between planes, but their main purpose seems to be to create a dialogue with the coloured planes and especially with the 'jewels', the little shapes that spangle the surface of the whole. As time went on Klee developed these detached lines to form a language of their own. Meanwhile, as *Stage Landscape* (Fig. 29) shows, the newer style of drawing still allows scope for Klee's special wit. Only the title would mark this out as one of his stage pictures; the staring eye might suggest a view from the stage, rather than of it.

Fig. 29
Stage Landscape

1937. Pastel. Private
Collection, Bern

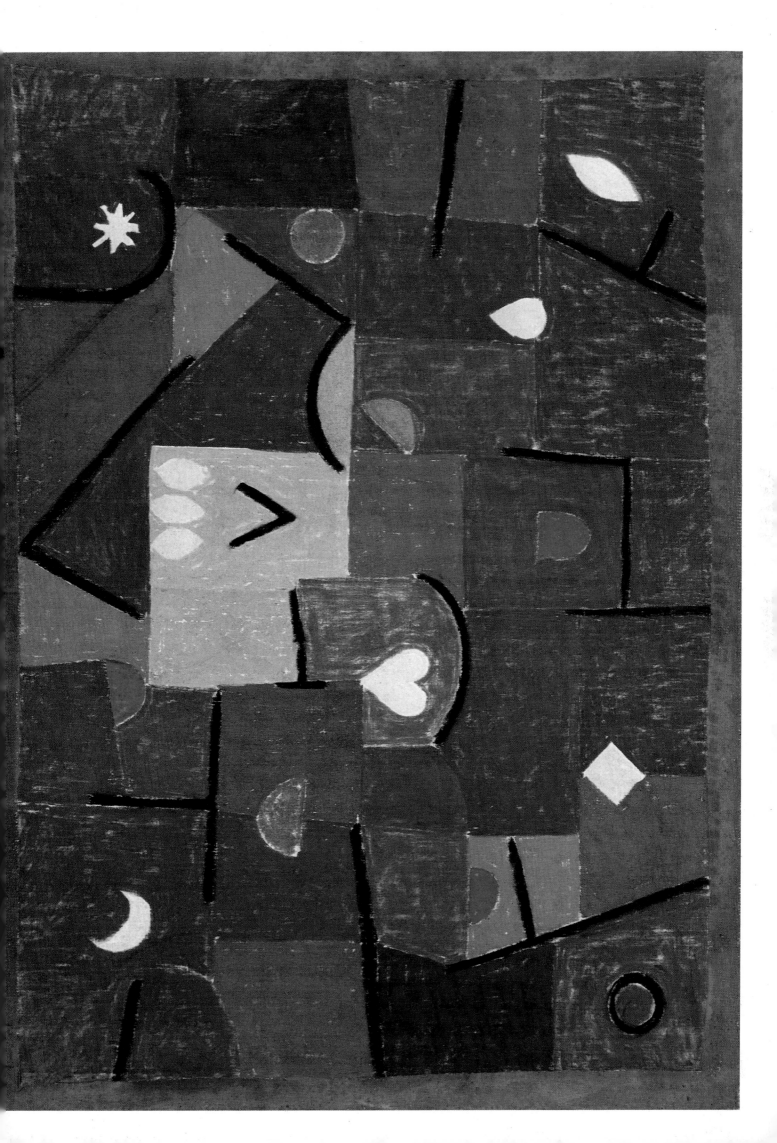

Contemplating

1938. Paste colour on newsprint, 47.2 x 65.8 cm. Galerie Beyeler, Basel

In Plate 40 the method of composing with broken and fragmentary lines, referred to under Plate 29, comes into its own without the counterpoint of coloured planes. Here the lines are longer, more curvaceous and involved, but they seldom touch, or form into an enclosed figure. The effect is to set the whole surface alive with possibilities, as our eye seeks to relate these graphic marks to one another, or to complete in the imagination the relationship that Klee has already suggested. The face looking out at us from the left centre may have prompted Klee's title, but there are still at least six other eyes visible, and other configurations that may denote faces. As noted in the text none of these images is located in space, unless it is the square walking on short legs along the bottom edge of the composition. It is the existence of so many presences haunting the surface that gives this prime example of Klee's late compositions its peculiar fascination.

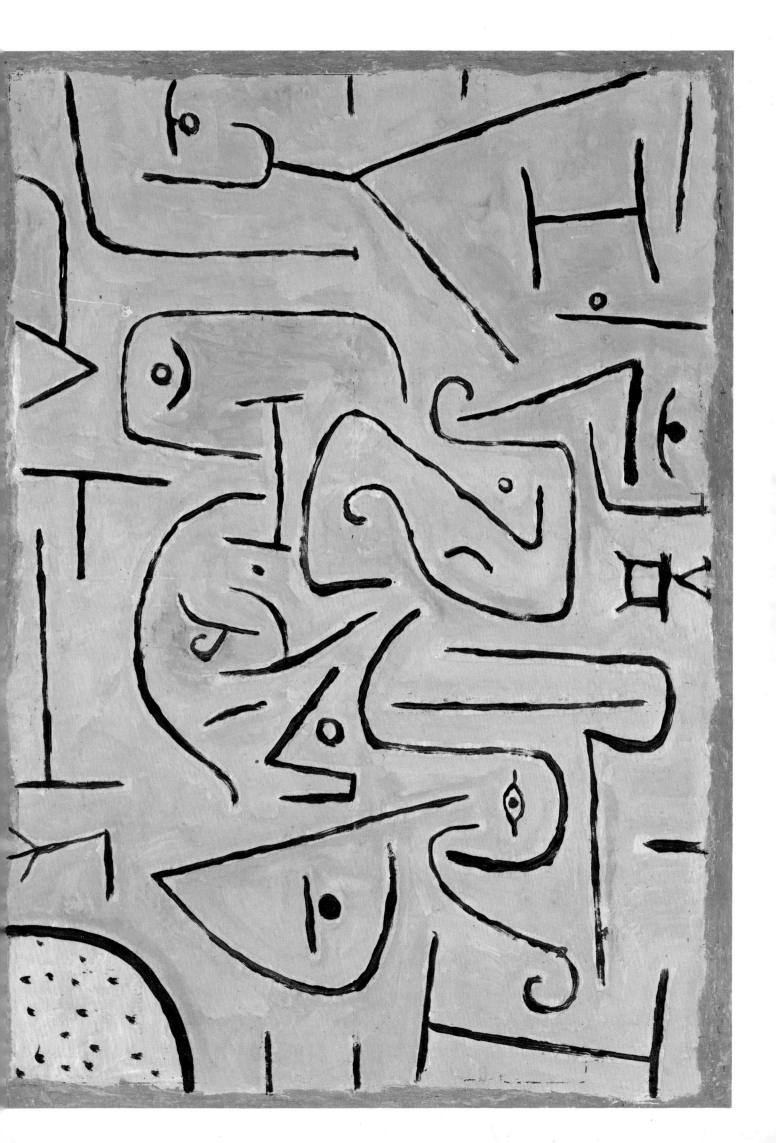

1938. Oil on stained canvas, 68 x 52 cm. Kunstsammlung Nordrhein-Westfalen, Düsseldorf

The title of Plate 41 reminds us that Klee's late and apparently more abstract manner did not break the intimate connection between his art and nature. The origin of the disjunctive, almost dismembered pieces of line so evident in the last two Plates, may be found in his drawings of plants and insects. Two forms often used in the late years are among the basic building-blocks of growth – the fork or branch, and the spiral. Klee entitled a drawing of 1937 *Forkings and Snail*. But subsequent uses of these forms were not confined to entomology and could, under Klee's sardonic eye, take on surprising likenesses. Only he could couple the concepts of 'rose' and 'heroism', but the energy generated by the bold spirals, forkings and zig-zags justifies the paradox. Even more paradoxical is a painting of the same time where the angular spiral takes on the appearance of a stout figure in an attitude of fear or hesitation, to which Klee attached the title *Timid Brute*.

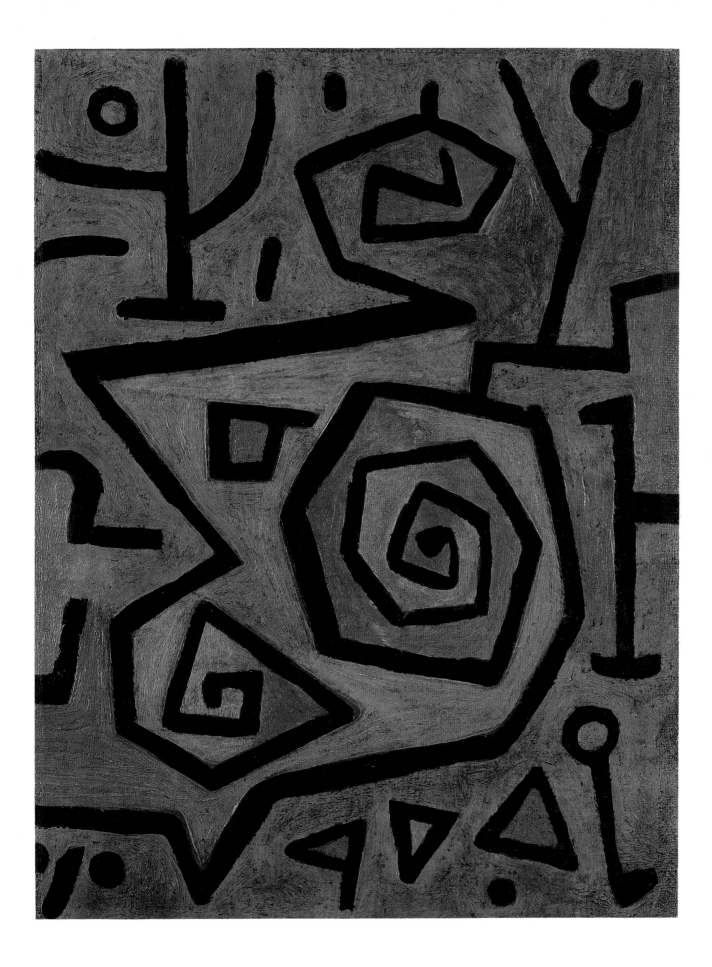

Red Waistcoat

1938. Paste colour, waxed, 65.1 x 42.5 cm. Kunstsammlung Nordrhein-Westfalen, Düsseldorf

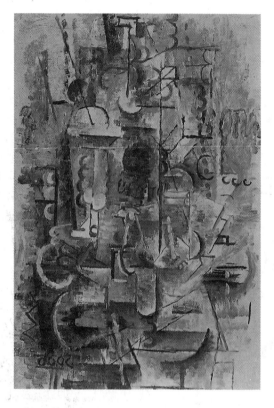

Fig. 30
Braque:
Bottle and Glass

1912. 55 x 38 cm.
Private Collection, Bern

It is suggested in the introductory text of this book that the use of fragments of discontinuous line in late Klee might have been derived from Cubism. On his return to Bern, Klee must have seen examples of Analytical Cubism in Swiss collections, such as Fig. 30, which was in the possession of his patron Hermann Rupf. The use Klee made of such lines is of course utterly different, but it shares with Cubism the capacity to hint at forms rather than spell them out, and to suggest relationships not just around the central features of the composition but over the whole surface. Klee adds something more – an energy which derives from his supreme management of *interval*. Wherever lines come close to one another but do not touch, energy is created, as half-open doors create draught or chinks focus light. The animation that comes from this source permits an astonishing number of ambiguous forms to exist independently within the picture, each signalling its existence but all in perfect harmony.

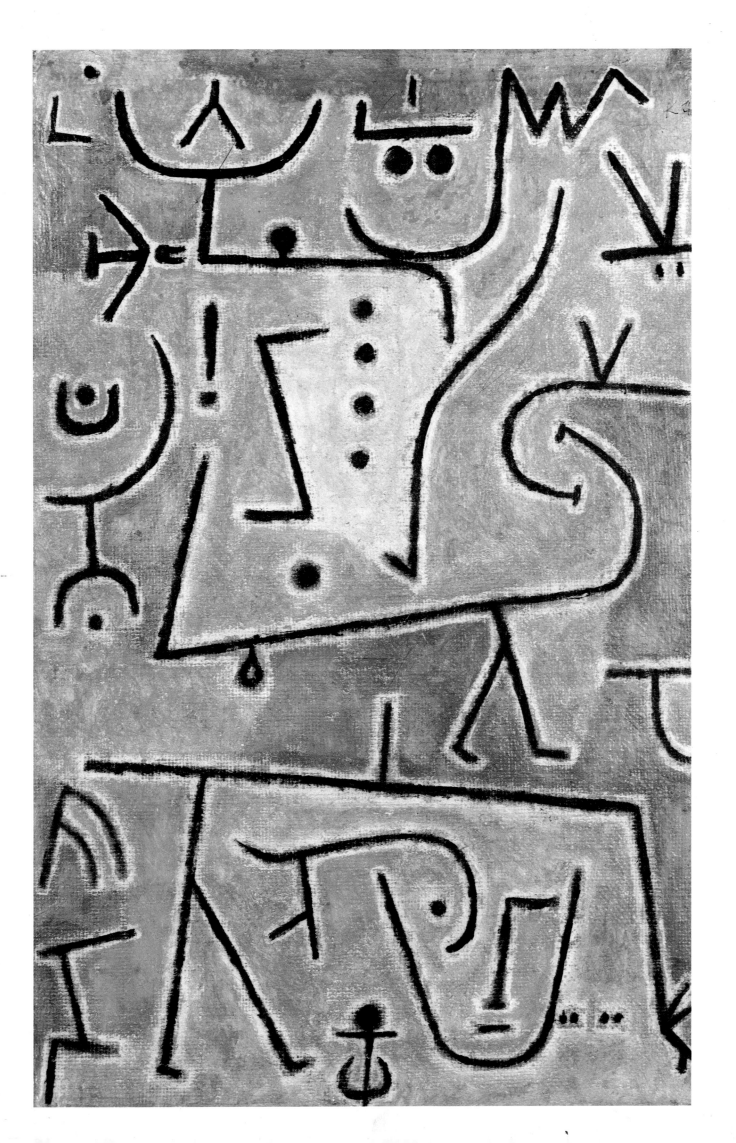

Park near Lu(cerne)

1938. Oil on panel, 100 x 70.2 cm. Paul Klee Foundation, Kunstmuseum, Bern

Park near Lu is perhaps Klee's last great nature painting. At no time did Klee ever set out to represent the surface attraction of parks and gardens; as we have seen, his approach was far more analytical. Yet here, in the middle of his late period, using only the most basic symbols of growth, he sings an unsurpassed hymn of praise to the beauty of nature. The picture has the characteristics of the late style without its asperities, and without the rather disturbing appearance of half-concealed sign-language such as can be seen in Plates 40 and 42. The absence of 'readable' signs (only the central tree motif is of this kind) makes it easier to appreciate the principle of composition by interval, as discussed in the text and in the commentary on Plate 42. In *Park near Lu* there is a new relationship between the black linear elements and the background, with each element surrounded by its own broad penumbra of colour.

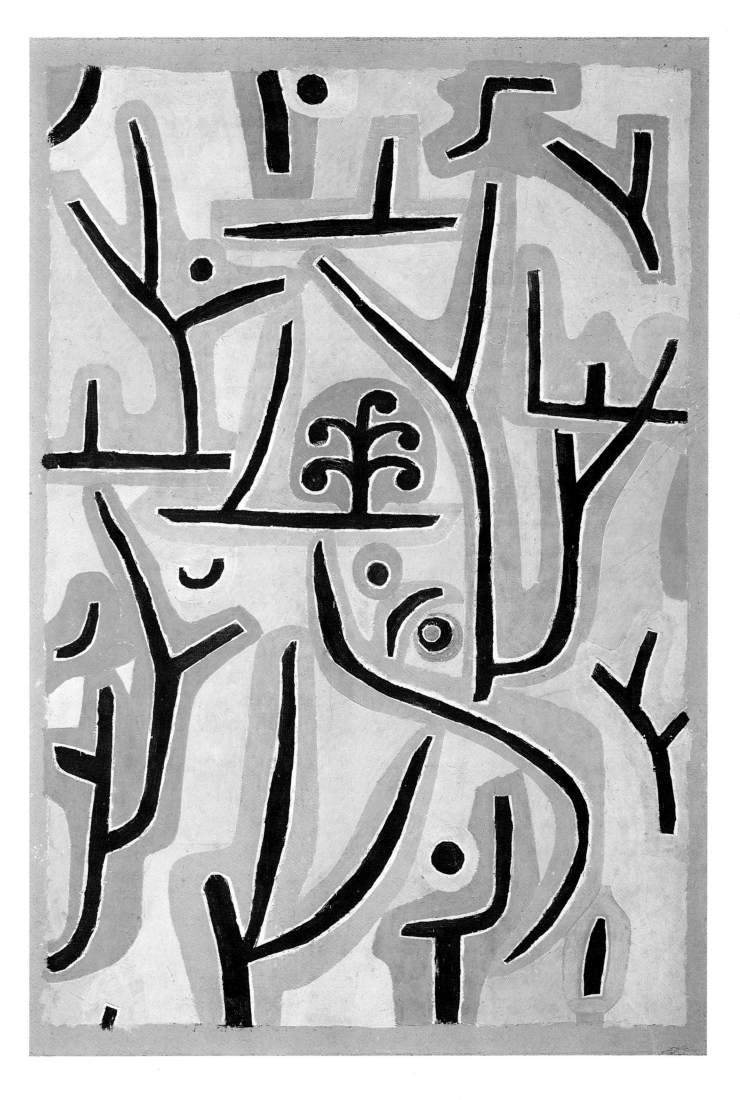

Outburst of Fear

1939. Watercolour on paper prepared with tempera, 63 x 48 cm. Paul Klee Foundation, Kunstmuseum, Bern

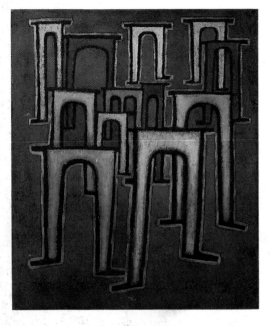

Fig. 31
Revolution of the Viaduct

1937. Kunsthalle, Hamburg

The grim undercurrent to the late work of Klee, resonating painfully between his own illness and the torment of Europe, comes dramatically to the surface here, in stark contrast to the serenity of Plate 43. Two things happened to Klee's drawing (that is, his way of composing his visual ideas) in the last years. One, which we have seen clearly already, is that the continuous line splits up into fragments. The other is plainly visible in some of his monochrome drawings which depend on line alone, where the line does not break up but goes on folding over and over itself like some growth that has run out of control. Applied to his depictions of animal and vegetable forms, this can result in a disturbingly hybrid, mutant or diseased aspect. Plate 44 seems to show something of both of these developments. Each form is enclosed, distinct and does not touch its neighbour, but one of them at least is also convoluted and organic in a somewhat repellent way. By introducing a hand and a terror-stricken face, Klee has chosen to turn the whole ensemble into an image of human dismemberment, but his title invites us to consider this not in the physical sense but as an analogy of mental and psychological break-up under extreme stress.

In another, much discussed image Klee used the theme of dismemberment to indicate disruption of a social nature. This is *Revolution of the Viaduct* (Fig. 31), where the arches have broken ranks to go their own way. The exact political interpretation of the image has been debated, but the analogy between formal and functional disorder could hardly be clearer.

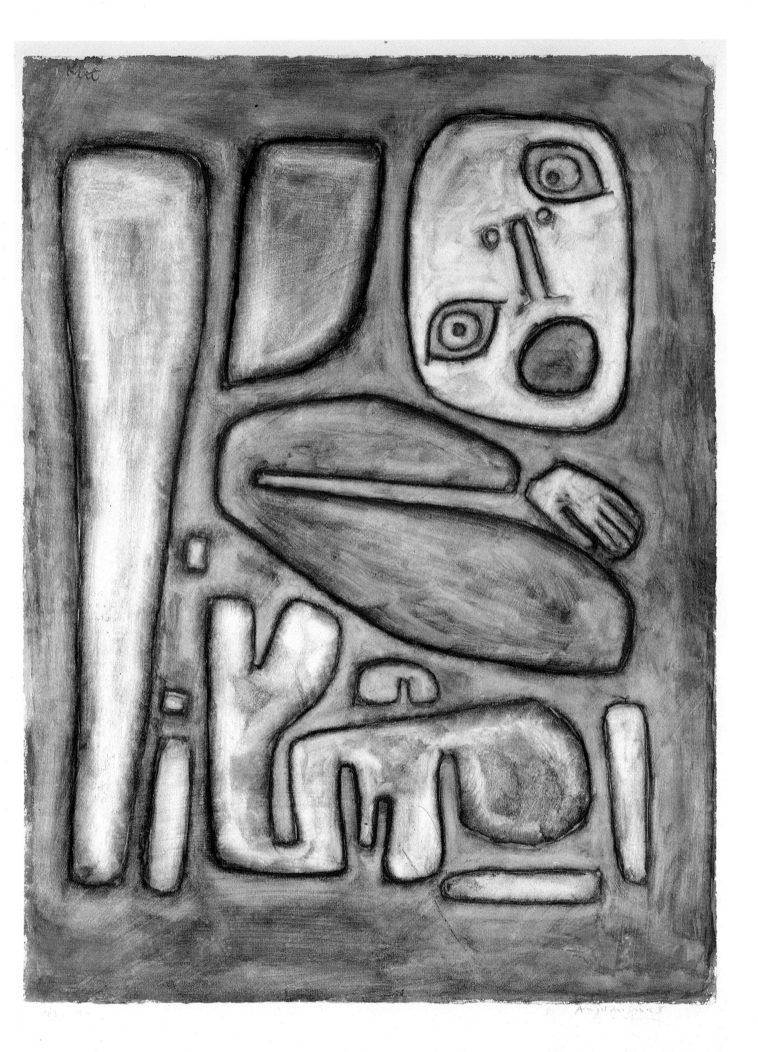

Mephisto as Pallas

1939. Tempera and watercolour on black prepared paper, 90.5 x 150 cm. Ulmer Museum, Ulm

Plate 45 belongs with the bitter-sweet part of Klee's late work, in which all that has been said here of his awareness of death, and its tragic expression, is true but comes to the surface in forms of wry humour. The most typical expression of this frame of mind is the series of *Angels*, consisting of many drawings and a few paintings. Klee identified with these beings whom he represented not as angelic but as most imperfect, indeed suffering creatures who were nonetheless destined to be admitted to paradise. Not all of the series bear the name of angel, so we may include in it both Plate 45 and Fig. 9. Klee's sombre wit is seen as much in the titles of such works as in the works themselves. It was the form twisting and flowing under Klee's frail hand that prompted the thoughts behind the title here – the crumpled face and Mephistophelian grin surmounted by the plumed helmet of Pallas Athene, goddess of wisdom. No doubt the irony and paradox were not lost on Klee, of all artists the most susceptible to them.

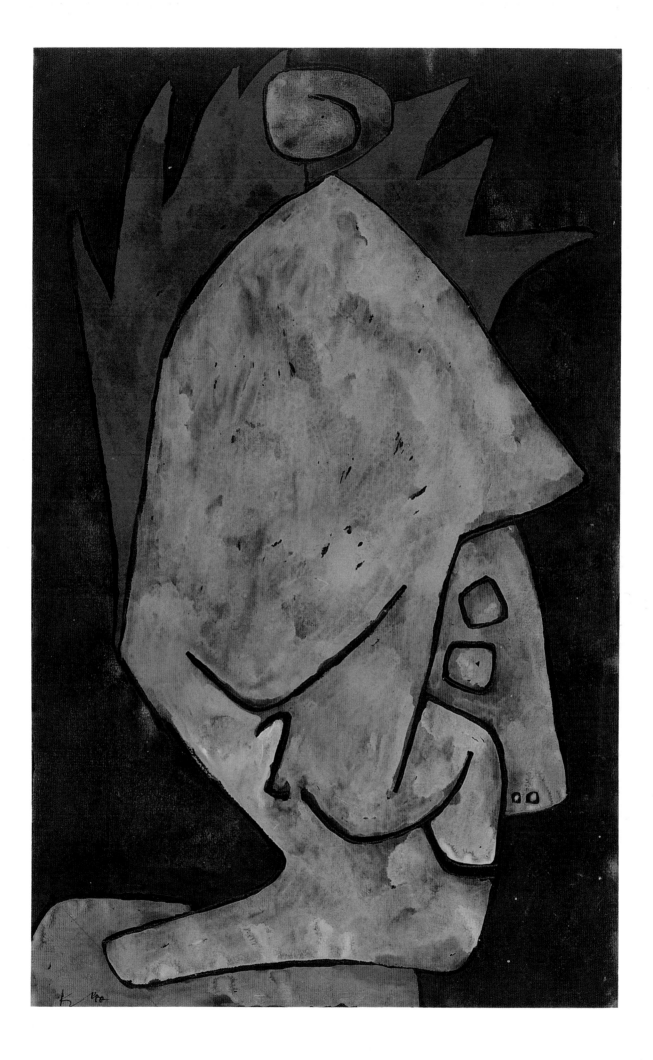

Woman in Peasant Dress

1940. Paste colour on paper, 48 x 31.7 cm. Paul Klee Foundation, Kunstmuseum, Bern

The characteristics of Klee's late style as already noted were not, of course, applied to every work of that period. Here, in a work of the last six months of his life, the black lines are not fragmentary. On the contrary they form thick continuous walls within which the colours enclosed shine like coloured glass. As in Plate 37, for example, it has taken very few marks of the brush to adapt an abstract composition to a human likeness. The shapes of the headdress, which prompted the title, were probably part of the evolving structure, and the orientation of the canvas may not have been settled until the eyes and mouth were added. Thus the work is a late example of a method to which Klee was thoroughly accustomed. What marks it out as a very late picture is the thickness of the line, the simplicity of the means employed, which Klee's physical weakness and, no doubt, his diminishing attention-span, enforced on him. There is no tragedy, no shadow even, in the title Klee has given it, but the startling appearance of the chalk-white face, in the context of Klee's last months, must come as a reminder of mortality.

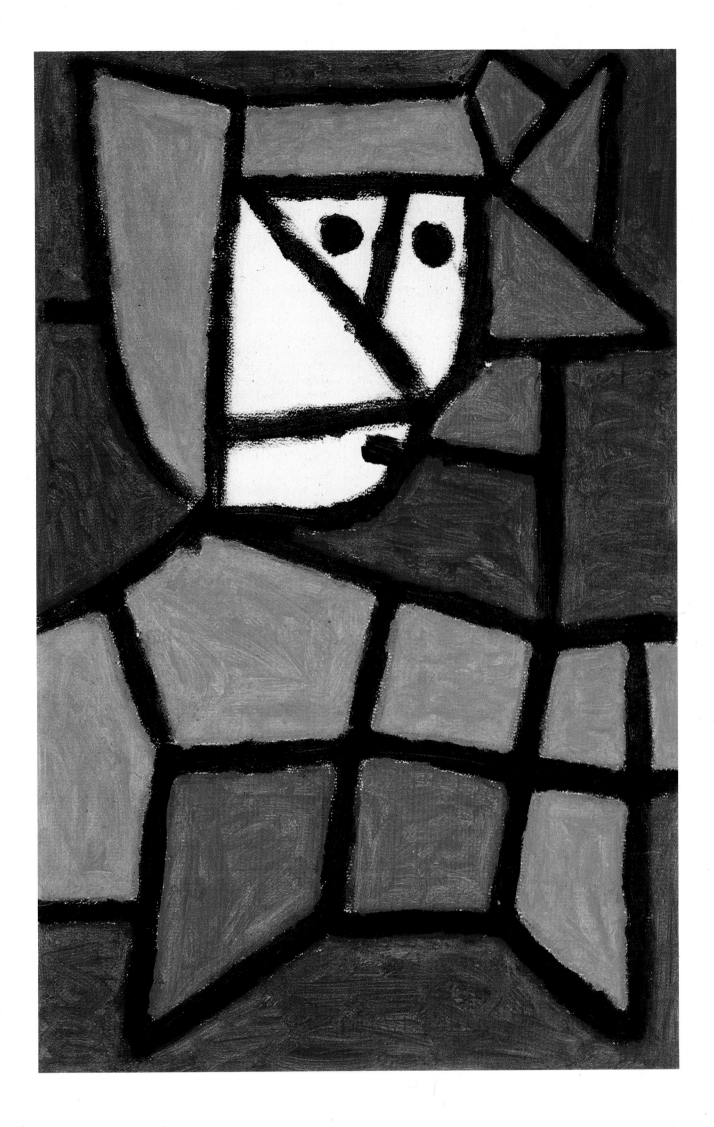

Kettledrummer

1940. Paste colour on paper, 34.4 x 21.7 cm. Paul Klee Foundation, Kunstmuseum, Bern

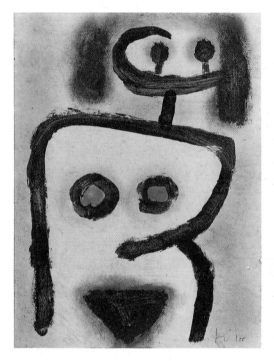

Kettledrummer is one of a few very late works in which Klee's linear short-hand is pared down to its most expressive minimum. The drummer's arms have themselves become drumsticks, of which one is raised vertically in a gesture of chilling finality. The head, defined by a single loop of the gross black line, contains one feature only, an unwinking eye. This head sees all, but communicates nothing, except the unremitting beat of the drum. The eye still transfixes each spectator, but it was surely Klee himself who was the first object of its baleful stare, and who felt the beat and roll of the drum as a symbol of his own approaching death. It is reported that when delirious in the later stages of his illness, Klee would attempt to reproduce vocally the drum passages from Mozart's *Requiem*. Klee seldom used colour in such a minimal way as here, with hasty patches of red to hammer home the painful directness of the message. Yet withdrawal from colour was not in itself a mark of imminent death. The picture on his easel when he died was a highly coloured, complex and metamorphic still life. The year before, Klee's irrepressible wit had produced a memorable double image, both face and female torso (Fig. 32). It is a conceit worthy of Surrealism, but employs the same starkly minimal means of expression as he used to drive home the pathos of his vision of the fatal drummer.

Fig. 32
A Face, also of
the Body

1939. Private Collection,
Switzerland

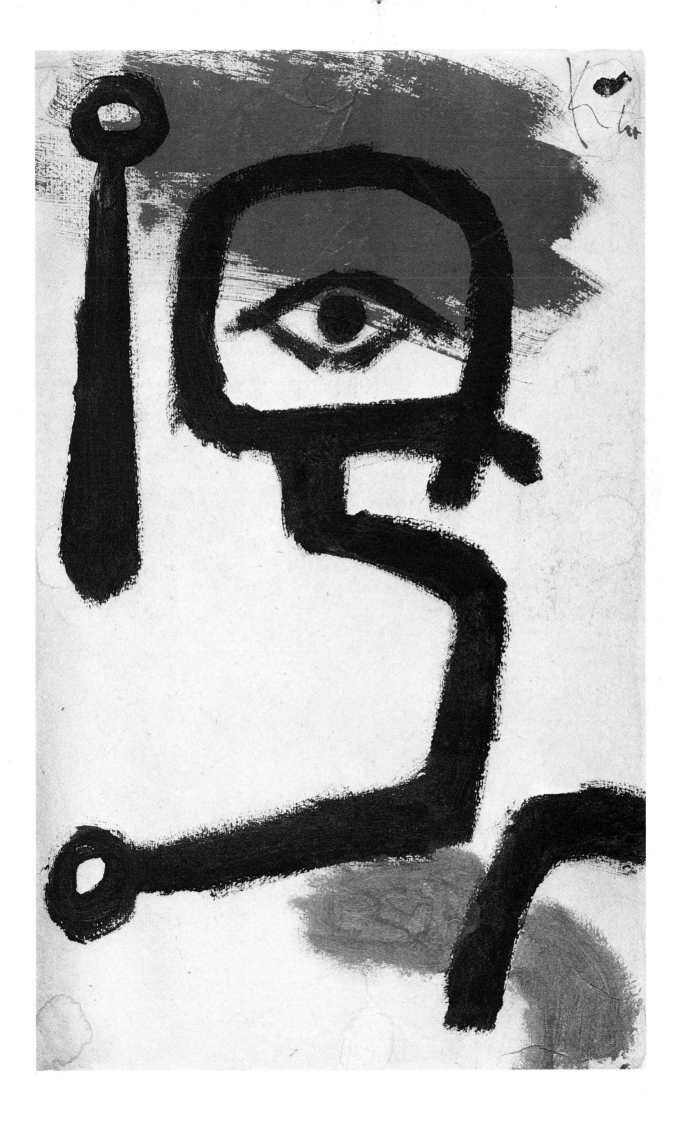

Death and Fire

1940. Oil on panel, 46 x 44.1 cm. Paul Klee Foundation, Kunstmuseum, Bern

This moving work can be considered as Klee's last self portrait. Its technique and form are consistent with the development of the late style as we have seen it, the preparation of the canvas and the application of the paint reduced to a minimum. Even this minimum, it seems, is fading, the pigments barely brushed into the coarse grain of the canvas and the thick black line wavering in its density. Whether or not this was actually the result of physical weakness, it conveys a touching impression of bodily fading and withdrawal from life. The title speaks of a deeper involvement with the last things. Unlike Plate 46, this composition was surely intended from the beginning to present the image it does. The figure on the right, so alarming and imposing in its simplicity, was always a figure; the death-head always a head. The symbolism of the parts has stimulated discussion of Klee's state of mind. On the whole he seems to have been accepting of death and happy in a life's work that had brought him nearer to an understanding of creation. Even though it was not the last picture he worked on, *Death and Fire* will always be Klee's most fitting epitaph.

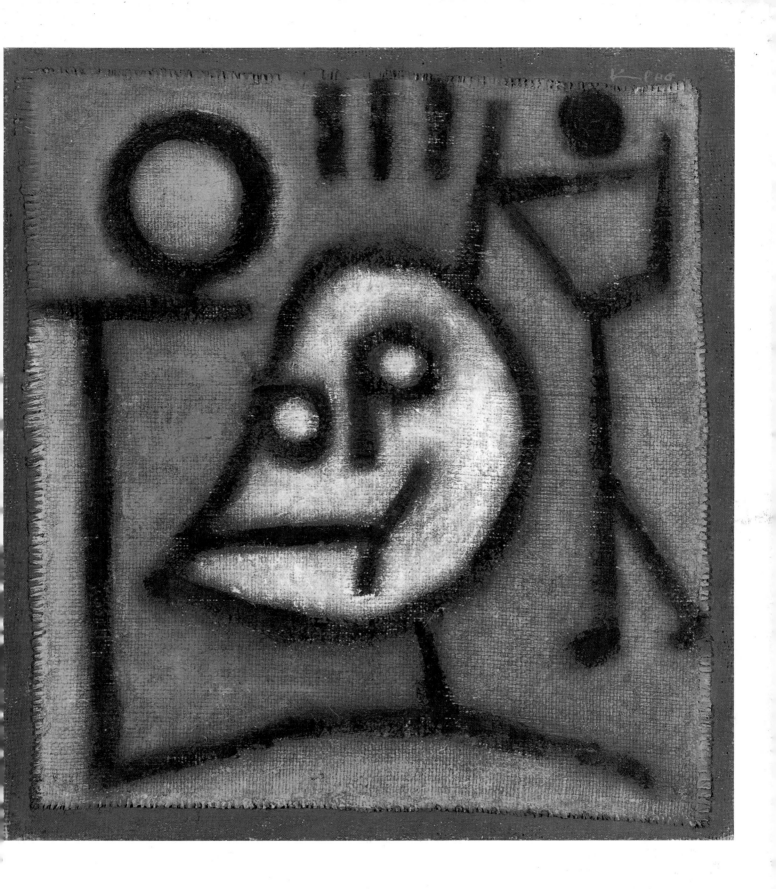

PHAIDON COLOUR LIBRARY

Titles in the series

BRUEGEL
Keith Roberts

CEZANNE
Catherine Dean

GAUGUIN
Alan Bowness

JAPANESE COLOUR PRINTS
J. Hillier

KLEE
Douglas Hall

MATISSE
Nicholas Watkins

MONET
John House

THE PRE-RAPHAELITES
Andrea Rose

PICASSO
Roland Penrose

REMBRANDT
Michael Kitson

SURREALIST PAINTING
Simon Wilson

VAN GOGH
Wilhelm Uhde

CONSTABLE
John Sunderland

MANET
John Richardson

RENOIR
William Gaunt

DEGAS
Keith Roberts

MODIGLIANI
Douglas Hall

TURNER
William Gaunt

MAGRITTE
Richard Calvocoressi